IMAGES
of America

COCONUT GROVE

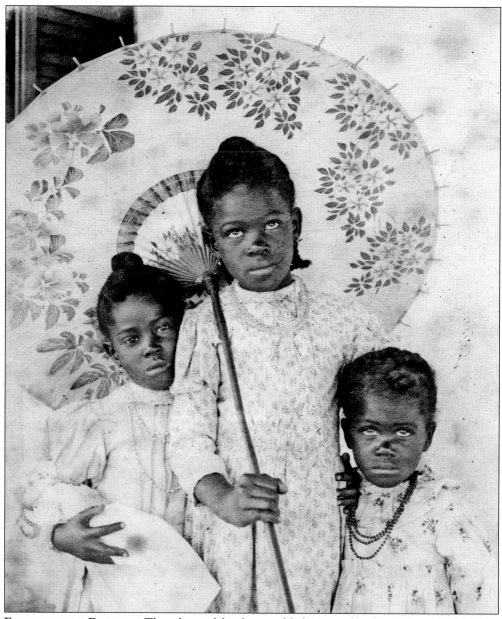

FACES FROM THE FRONTIER. These beautiful girls, most likely sisters, lived in Kebo, today's Village West and the first black community on the South Florida mainland. (MCHMSF.)

ON THE COVER: THE JOYS OF CHILDHOOD. Little Eunice Peacock, granddaughter of Charles and Isabella and future wife of Coral Gables founder George Merrick, joins her cousins and friends in a photograph taken at her home around 1897. Eunice's lifelong love of animals began with her pet goats. (MPCUM.)

IMAGES
of America

COCONUT GROVE

Arva Moore Parks and Bo Bennett

ARCADIA
PUBLISHING

Copyright © 2010 by Arva Moore Parks and Bo Bennett
ISBN 978-0-7385-8627-4

Published by Arcadia Publishing
Charleston SC, Chicago IL, Portsmouth NH, San Francisco CA

Printed in the United States of America

Library of Congress Control Number: 2010923206

For all general information contact Arcadia Publishing at:
Telephone 843-853-2070
Fax 843-853-0044
E-mail sales@arcadiapublishing.com
For customer service and orders:
Toll-Free 1-888-313-2665

Visit us on the Internet at www.arcadiapublishing.com

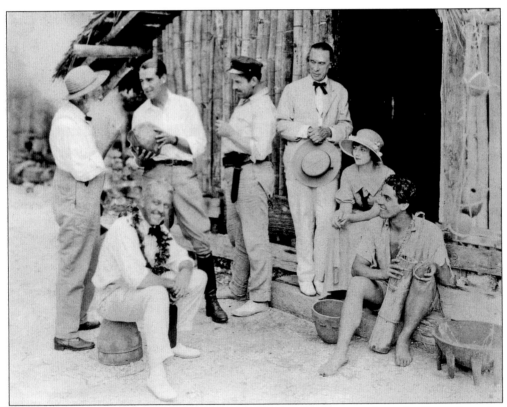

MATINEE IDOLS. In 1922, legendary Hollywood director Rex Ingram chose the Barnacle as the site for his silent film *Where the Pavement Ends*. Ralph Munroe greeted the famous cast in front of one of the Samoan huts built on the bay front. From left to right are Ralph Munroe, Rex Ingram, an unidentified actor, John George, Alice Terry, and Ramon Novarro. The man seated on the left is unidentified. (Arva Moore Parks.)

CONTENTS

ACKNOWLEDGMENTS

My career began when, as a graduate student in American history, Dr. Charlton Tebeau pushed me toward Miami history and became my mentor. Following his lead, I completed my master's thesis on the history of Coconut Grove in 1971. This put me in contact with many Coconut Grove pioneers, including Mary Munroe, Patty Munroe, Bill Catlow, Gertrude and Olga Kent, Kate Stirrup Dean, Fr. Theodore Gibson, and Eunice Peacock Merrick. Unfortunately, all of these special people are not here to comment on this book, but it would not have happened without their help and encouragement. Mildred Merrick continues to inspire and prod me.

Everyone named in the photograph credits has contributed, and we are grateful for their help. Several people—including Finlay Matheson, Gael Stanley, Bob Simms, Michael Carlebach, Klara Farkas, Ken Treister, Glenn Terry, Sally Browne, Virginia and Dean McNaughton, Tucker Gibbs, Thelma Anderson Gibson, and the Woman's Club of Coconut Grove—provided multiple images, as did the late Ken DeGarmo, Joe Pero, and Estelle Overstreet. Others who opened doors and went out of their way to help are Dennis Wilhelm, Max Blumberg, Andy Parrish, Gordon Fales, Georgette Ballance, Sonia Robinson-Scott, Toby and Celeste Muir, Tom Falco, Ann Parsons, Teresa Valdes-Fauli Weintraub, Lamar Noriega, Sonia Chao, Harry Gottlieb, Lynn Summers, and Beth Dunlop. I am honored that many professional photographers allowed me to use their images, and that institutions, like the University of Miami Special Collections and the Historical Museum of Southern Florida, did as well. I am especially grateful to Dawn Hugh of the Historical Museum of Southern Florida and Dean Bill Walker, Cristina Favretto, and Rochelle Piemm of the University of Miami Libraries for their help.

It has been a pleasure to work with Bo Bennett, who has added a new perspective to Coconut Grove's history and has become a friend. Finally, I am grateful to my husband, Bob McCabe, who continues to encourage me in whatever I do.

—Arva Moore Parks

I would further like to thank Jay Ziskind, Dan Cahill, Vicki Jugenhiemer, Tatiana Steward, Tiger Taganas, and Maria Sardon for their support during this project. I am especially grateful to my family for all their patience and understanding while I was away working on this endeavor. Lastly, and most graciously, I would like to thank Arva Parks for being a friend and a mentor in sharing her vast wealth of knowledge and photographic archives that enhanced the caliber of this book.

—Bo Bennett

KSD	Kate Stirrup Dean
MCHMSF	Munroe Collection, Historical Museum of Southern Florida
MCUM	Michael L. Carlebach Photographic Collection, Special Collections, UM Libraries
MFC	Matheson Family Collection
MFCUM	Munroe Family Collection, Special Collections, UM Libraries
MH	*Miami Herald*
McN	McNaughton Family Collection
MPUM	Merrick-Peacock Collection, Special Collection, UM Libraries
NA	National Archives
R	Romer Collection, Miami-Dade Public Library
SB	Sally Browne
SPA	State of Florida Photographic Archives
TGAG	Tucker Gibbs, Asa and Harriet Gardiner Collection
TGVP	Tucker Gibbs, *Village Post*

REMEMBERING THE FOUNDERS. Leona Peacock Cayton, great-granddaughter of Charles and Isabella Peacock, portrayed her great-grandmother during Coconut Grove's 1973 centennial celebration. (GS.)

INTRODUCTION

Before it had a name, Coconut Grove attracted people. Lapped by the clear waters of Biscayne Bay, the land laid waiting—a tangle of fertile hammock and spreading pineland perched high atop a fortresslike ridge.

Biscayne Bay was the highway, and a natural channel made it easy to come ashore. Prehistoric Native Americans found it, and Spanish sailors noted its fresh water. Bahamian and New England wreckers sometimes called it home, but its isolation made permanent settlement elusive.

This changed in 1884 after Staten Island visitor Ralph Munroe convinced Charles and Isabella Peacock to build a hotel in the wilderness to give people a place to stay. From this launching pad, a remarkable group of people—both black and white—built the first schools, stores, libraries, and churches.

The dawn of the 20th century brought in industrialists and men and women of arts and letters. They built winter homes on the bay front and helped define what Coconut Grove would become.

When World War I broke out, the small island of Dinner Key became home to one of the nation's first naval air stations. Residents remained silent until the war ended, but when Miami leaders wanted to make the station permanent, Grove voters incorporated the Town of Coconut Grove to gain more muscle against the ever-expanding city. Even after Miami annexed Coconut Grove against its will in 1925, residents refused to give up their identity and simply become part of Greater Miami.

Although no longer a separate city, Coconut Grove remained relatively unchanged until the 1960s when the City of Miami approved the first high-rise buildings. The arrival of the "flower children" added to the turmoil and tested the Grove's famous live-and-let-live tolerance. But while many mourned the passing of the old Grove, an equal number worked to protect it and keep its soul alive.

Today, amidst staggering pressures, the spirit of Coconut Grove lives on. It swirls in the billowing sails of boats on Biscayne Bay. It gains strength from its history carefully stored in a myriad of special places. It thrives in its verdant tree-lined, winding streets and in the Bahamian-style homes of Village West. It flares anew when stalwarts stand up against overdevelopment and greed and try to regain independence. Despite change and often painful loss, Coconut Grove remains unyieldingly and uniquely itself.

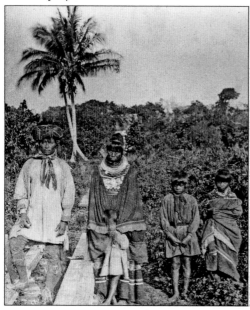

JIMMY FAMILY. The Jimmy family posed on the Coconut Grove bay front near its two famous coconut trees. Early landowner John Frow built the Three Sisters House, visible in the background, with wood from the shipwreck of the brig *Three Sisters*. (MCHMSF.)

One

THE LITTLE

HUNTING GROUNDS

Thousands of years before Europeans discovered South Florida, a group of tall, handsome, and well-developed people populated the area. When the Spanish arrived in 1513, they called them Tequesta Indians. Recent archaeological investigations have documented their presence in Coconut Grove.

When the Spanish gave up possession of Florida to England in 1763, most of the native people fled to Cuba with the Spanish, leaving South Florida barely inhabited. Native Americans of Creek descent, known as Seminoles, filled this vacuum along with a group of fishermen and wreckers from the Bahamas. Pirates too roamed the waters, and at least one, known as Pirate Lee, built an outpost on the Coconut Grove ridge.

In 1819, when Florida became a territory of the United States, two people claimed (one succeeded in proving) they occupied land during the Second Spanish Period in what later would become part of Coconut Grove. Jonathan Lewis received title to his settlement, including what early settlers called the Devil's Punch Bowl. Although the U.S. government declined Bahamian Temple Pent's claim, his children were the earliest permanent inhabitants of Coconut Grove.

Conflicts between the United States and the Seminoles during the Second (1836–1842) and Third Seminole Wars (1855–1858) inhibited settlement but inadvertently gave Coconut Grove its first name—the Little Hunting Grounds—scrawled on a military map.

The fact that the Seminoles hunted in the area did not stop a few brave souls from squatting on the land. John Dubose, the first Cape Florida lighthouse keeper, built a home for his family in what he described as "the land across from the light." Members of the Pent family, who also tended the light, did the same. When the Seminoles attacked and burned the lighthouse in 1836, most of the people abandoned the area—at least temporarily. Twenty years later, when conflict again erupted, the Native Americans attacked and killed Peter Johnson and Edward Farrell at their comptie mill located on land across from today's Coconut Grove Playhouse.

By the late 1880s, the Native Americans were no longer adversaries but frequent and welcome visitors to the pioneer settlement of "Cocoanut Grove." Ralph Munroe, South Florida's first photographer, captured some of the earliest known images of the Seminoles and the primeval wilderness they inhabited.

KEY BISCAYNE BLUFFS. These beautiful bluffs, located on today's Brickell Avenue, commanded the bay front. In 1771, British surveyor Bernard Romans noted this "rocky bluff" on his map. Today huge condominiums occupy the mostly leveled site. (MCHMSF.)

THE DEVIL'S PUNCH BOWL. Located on Brickell Avenue near Rickenbacker Causeway, this natural spring bubbled up from a perfectly cut circular well built by early settlers. Barely noticeable on the far right is a man drinking what one pioneer described as "the purest ale Adam or his descendents ever brewed." (MCHMSF.)

HAMMOCK TRAIL. The pine and the palmetto country seemed to go on forever. The fernlike comptie (zamia) and the bushy palmettos thrived in what seemed like solid rock. A barely visible white-tailed deer meanders down the pathway. The deer, along with bears and panthers, had this land mostly to themselves. (MCHMSF.)

WALKING TREES. Mangroves are sometimes known as walking trees because of their unique prop roots. They are an integral part of South Florida's ecosystem and help preserve the coastline. This mangrove was located next to Kirk Munroe's private spring, where he was known to bathe. Neighbors knew to make noise as they were coming down the path to avoid catching him in his birthday suit! (TGAG.)

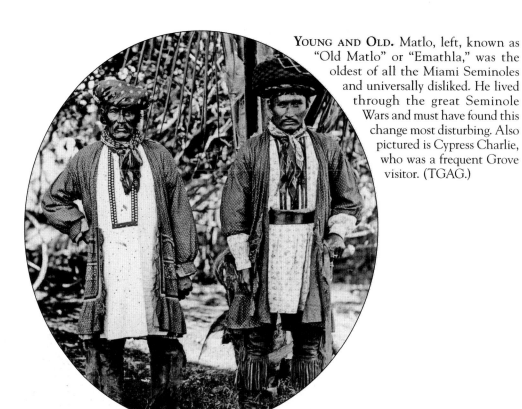

YOUNG AND OLD. Matlo, left, known as "Old Matlo" or "Emathla," was the oldest of all the Miami Seminoles and universally disliked. He lived through the great Seminole Wars and must have found this change most disturbing. Also pictured is Cypress Charlie, who was a frequent Grove visitor. (TGAG.)

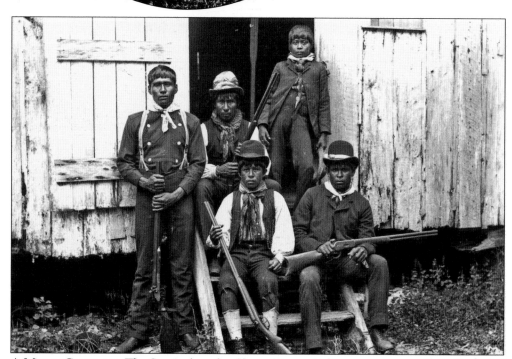

A MIX OF CULTURES. The Seminole style of long shirt and turban gave way to the influence of the trading post. Could that be an army uniform on the left? (MCHMSF.)

LITTLE TIGER.
Dressed in traditional Seminole clothing, Little Tiger posed with his gun. His turban also doubled as his bedroll. He was related to Dr. Tiger, who was the son of old Chief Tigertail of Seminole War fame. (TGAG.)

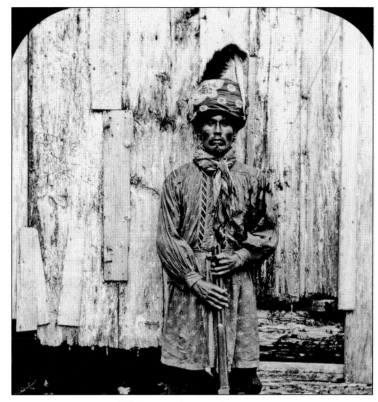

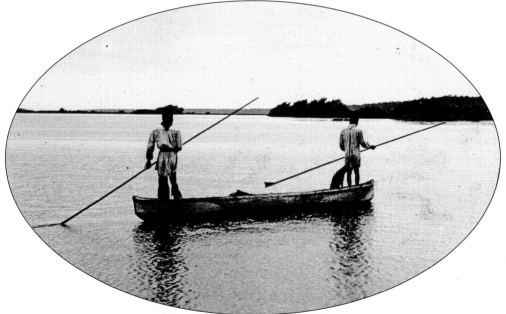

AVID TRADERS. Seminoles paddled their canoes down the Miami River from the Everglades to Brickell's Trading Post on the south bank of the Miami River. They traded venison, egret plumes, and alligator skins for beads, clothing, and liquor. They also frequented Coconut Grove and sometimes spent the night on the lawns of early settlers. (TGAG.)

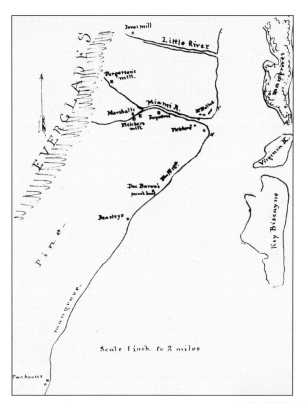

SETTLERS IN THE WILDERNESS. During the Third Seminole War, army mapmakers noted the presence of Edmund Beasley, Coconut Grove's first recorded settler. He homesteaded the heart of today's Coconut Grove in 1868. (NA.)

DR. HORACE PHILO PORTER, GAR. Although only a temporary resident, Union Doctor Horace Porter gave the community its name when he opened the "Cocoanut Grove" post office in 1873. He left shortly thereafter when he failed in his attempt to jump Edmund Beasley's homestead claim. (MCHMSF.)

Two

"COCOANUT GROVE"

Coconut Grove owes its name to the elusive Dr. Horace P. Porter, but its first documented landowner called it home almost four decades earlier. Edmund "Ned" Beasley was a mariner from Connecticut. He was well known for being one of the few to remain after the 1836 destruction of the Cape Florida lighthouse. Ned and his Bahamian wife, Anna, lived in a small log cabin with a thatched roof near today's Barnacle State Historic Park. An old well survives there to mark their presence. In 1850, Coast Survey mapmakers gave the name Beasley's Point to today's Coconut Grove.

In 1868, Beasley filed for the first homestead in Coconut Grove. Under the 1862 Homestead Act, the federal government granted any American citizen 160 acres of public land if he or she lived on the tract for five years, built a home, and raised a crop. Beasley's application was approved, but in 1870, before he could prove it up, he died.

Enter Dr. Horace Porter, a Yale-educated physician and former Union officer. Apparently, the widow Beasley rented her homestead to Dr. Porter thinking he was going to purchase it. When Porter realized it had never been deeded to Anna Beasley, he claimed it for himself. Anna Beasley's son wrote an impassioned letter to the land office protesting Porter's claim, and in 1873, after she prevailed, Porter left, never to return. But during his two-year stay, he managed to open a post office he named Cocoanut Grove and became its first postmaster. (Ironically, in 1877, Anna Beasley sold her entire 160-acre claim to Bahamian John W. Frow for $100.)

Time passed, and the Cocoanut Grove Post Office was forgotten until 1884 when newcomer Ralph Munroe discovered its existence in an old postal guide. Realizing it was easier to open an existing post office than a new one, Munroe had the Cocoanut Grove Post Office reopened even though there were only two coconut trees in the area.

Between the reopening of the post office and the birth of the City of Miami 12 years later, Coconut Grove thrived and prospered. By 1896, it had a hotel, a school, a yacht club, a women's club, a library, and a number of churches. When Julia Tuttle was trying to convince Henry Flagler to bring his railroad to Miami, she took him to the Grove's Peacock Inn for lunch. Impressed with the Coconut Grove settlement, he signed the deal.

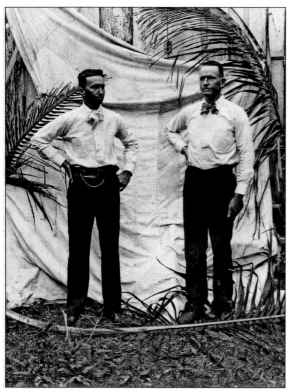

THE PENT FAMILY. After the Beasleys, the Pent family was the oldest family in the Grove. John Pent, right, and his brother Edward (Ned) lived on a homestead just north of the Beasley grant. John's father, Bahamian Temple Pent, came to Biscayne Bay in the early 19th century and was a former keeper of the Cape Florida lighthouse. Today Coconut Grove's Matilda and Mary Streets honor John Pent's wife and daughter. (MCHMSF.)

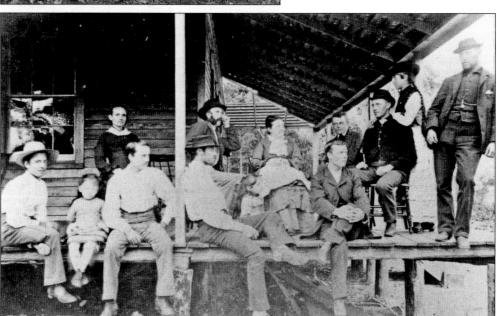

BAY VIEW HOUSE. The Peacock family, Charles and Isabella (center) and two of their three sons—Alfred (left of the post) and Harry (far right)—joined members of the Joseph Frow family, including wife Euphemia, rear left, and several other unidentified pioneers for this historic photograph taken in 1883 on the unfinished porch of the Peacock's Bay View House, Miami's first hotel. (MCHMSF.)

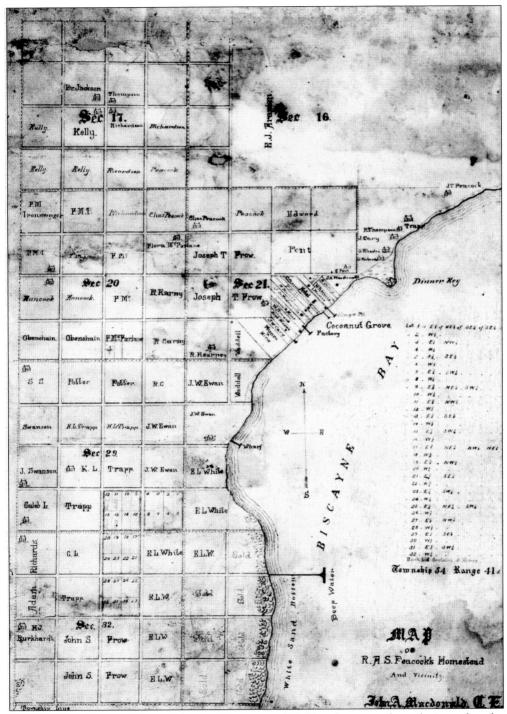

LAND FOR THE TAKING. Most of Coconut Grove was available to homesteaders, who carved up the land into 160-acre quarter sections. This homestead map identifies the owners of most of today's Coconut Grove and parts of Coral Gables and South Miami. (Eunice Peacock Merrick.)

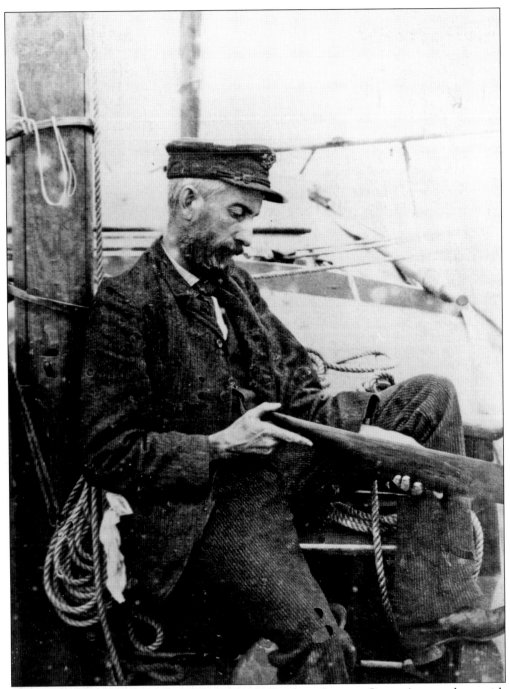

THE GODFATHER. Ralph Middleton Munroe left his mark on Coconut Grove. A nature lover with a special affinity for Biscayne Bay, he fought to keep Coconut Grove as he found it and spent his life trying to protect its unique subtropical ambiance. (MFCUM.)

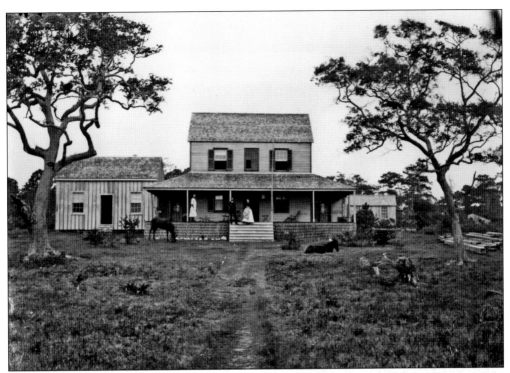

THE LAUNCHING PAD. The Bay View House was little more than a large home, but it attracted an interesting group of visitors who gave Coconut Grove its unique identity. (MCHMSF.)

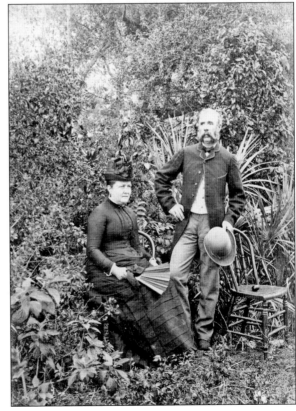

THE MOTHER. Charles and Isabella Peacock had a profound influence on the developing community. Residents fondly called Isabella Peacock "the mother of Coconut Grove." (MCHMSF.)

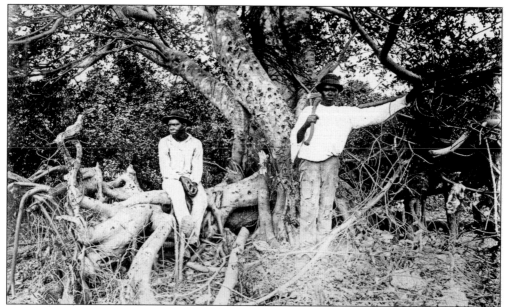

THE BUILDERS. Newcomers who trained in universities and finishing schools were fortunate to have the likes of Thomas and Zebedee to show them how to carve out a life in the mosquito-infested, junglelike wilderness. These early Bahamians also taught the white settlers how to grow tropical fruits and vegetables and provided the labor to bring about this change. They built South Florida's first black community, Kebo, just west of today's Main Highway. (MCHMSF.)

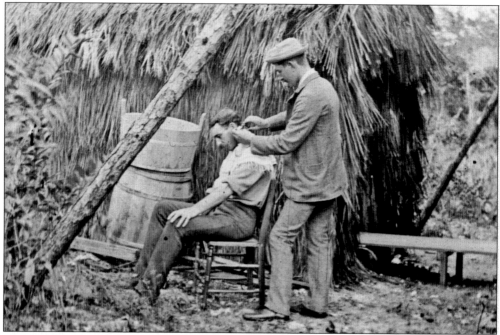

FRONTIER LIFE. Although this strange tropical land may not seem to fit the usual frontier mold, many aspects of life in early Coconut Grove were similar. People learned to improvise and help each other. Hair cutting in a barber-less wilderness was just one of the many cooperative ventures. (TGAG.)

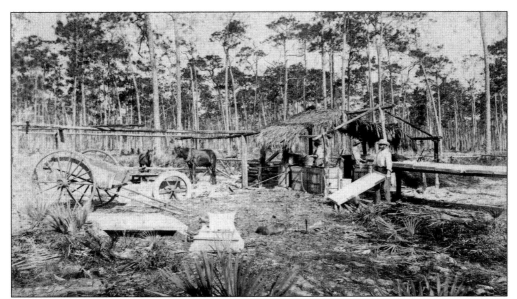

MAKING A LIVING. There was little need for cash on the frontier. When needed, everybody became a comptie digger and starch maker. The comptie plants grew wild in the pinewoods, and the Native Americans taught the settlers how to produce a type of arrowroot starch from their roots. It could be consumed by the family or sold in Key West for $10 a barrel. Charles Peacock's mill, seen here, was at the intersection of today's Main Highway, MacFarlane Road, and Grand Avenue. (MCHMSF.)

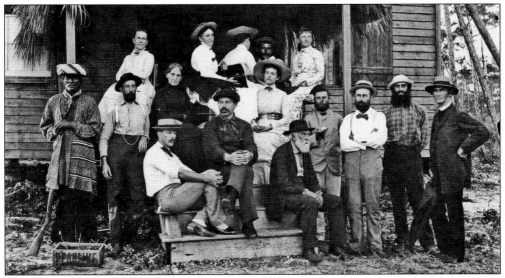

BRING IN THE TOURISTS. In 1887, the first winter visitors on Biscayne Bay launched South Florida's most enduring enterprise—tourism. From left to right are (first row) Kirk Munroe, famous author of boy's books; Count Jean D'Hedouville; and Alfred Munroe; (second row) Dr. Tiger; Ralph Munroe; Mrs. E. P. Brown; Miss Theodosia Brown; Charles E. Stowe, son of Harriet Beecher Stowe; Thomas A. Hine; Count James L. Nugent; and E. P. Brown; (third row) Mrs. Thomas Munroe (Ellen), Ralph's mother, and her companion, Flora Macfarlane; Mrs. Kirk Munroe (Mary Barr), who had a habit of turning her back to the camera; Edward A. Hine; and Mrs. Thomas A. Hine (Anna). (MCHMSF.)

AN ENDURING INSTITUTION. In February 1887, the Easterners decided that, with all the sailboats, they should have a boat race on Washington's birthday. Charles Peacock and Alfred Munroe were timekeepers and judges for South Florida's first aquatic event. The winners were William Brickell in *Ada*, Dick Carney in *Maggie*, and John Addison in *Edna*. After the race, all hands, about 50 in number, had a good dinner given by the promoters at Peacock's. A few months later, several of the men organized the Biscayne Bay Yacht Club with Ralph Munroe as commodore and Kirk Munroe as secretary. (MCHMSF.)

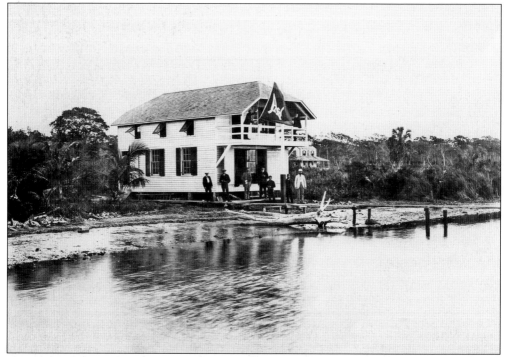

RAISING THE FLAG. Mary Barr Munroe, Kirk's wife, designed the Biscayne Bay Yacht Club "N-25" flag that was raised for the first time in front of Ralph Munroe's boathouse. (MCHMSF.)

Sunday School Picnic. Isabella Peacock organized community events to raise funds to build a Sunday school in the Grove. Most of Coconut Grove's pioneer families, including the Peacocks, Frows, Pents, Alburys, and Thompsons, came to the gatherings. Mariah Brown, the first black resident, stands in the background. (MCHMSF.)

Building Community. In 1887, Joseph Frow registered his son "Little Joe," who was not yet six years old, in order to meet the 10-child requirement for a new public school. In 1889, after two years in a private home, the school moved to the Sunday school building shown here. Flora MacFarlane became their teacher. The children are, from left to right, Leonard Albury, Maud Richards, Laura Richards, Charlie Frow, Gracie Frow, Joe Frow, Idell Thompson, Annie Peacock, Mary Serena Pent, Beverly Peacock, John Richards, Lillian Frow, John Pent, and Willie Richards. (MCHMSF.)

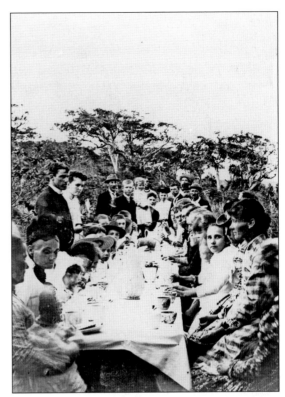

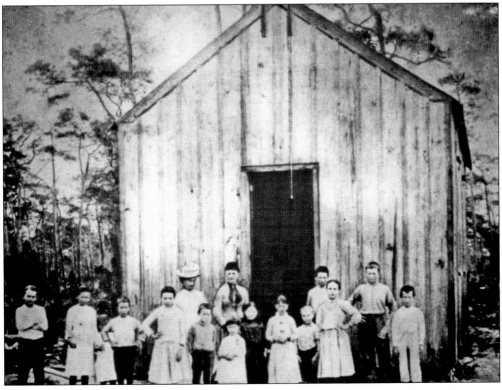

PIONEER WOMAN EXTRAORDINAIRE. Flora MacFarlane, South Florida's first female homesteader, spent her life encouraging, enlightening, and helping others. Her life's motto hung on the wall of the Housekeeper's Club that she founded in 1891: "I expect to pass through this life but once. Any good therefore that I can do, or any kindness that I can show to any fellow being—let me do it now. Let me not defer or neglect it for I shall not pass this way again." (MPCUM.)

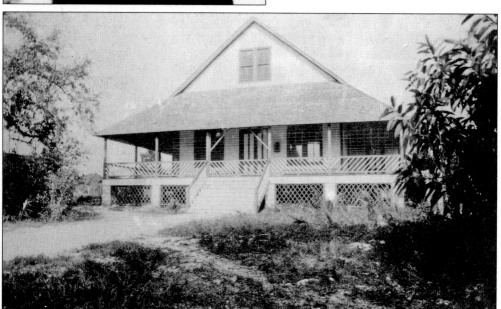

COMING TOGETHER. In 1897, the men in the community built the original clubhouse for the Housekeeper's Club on land that was donated by Ralph Munroe. Flora MacFarlane gave 5 acres of her homestead to the building fund, and Henry Flagler added an additional $100 to the cause.

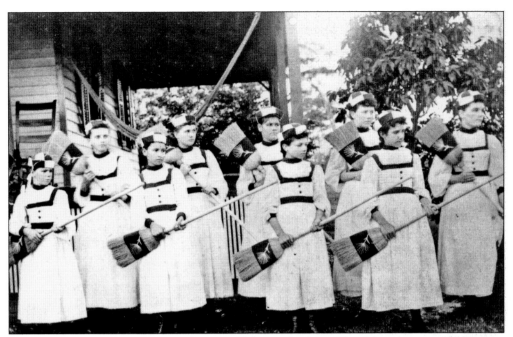

THE BROOM DRILL. In 1895, Housekeeper's Club member Mary Barr Munroe organized the Pine Needles Club for young girls. The girls were well known for the military-style broom drill that they performed at community events. Through Kirk and Mary Barr Munroe's leadership, the "Pine Needles" established the area's first library in a donated room on the second floor of the Charles Peacock and Son's store. (MCHMSF.)

FOOD FOR THOUGHT. Charles Peacock and his son Alfred operated Coconut Grove's first store in this two-story wooden building. It sat across from the Peacock Inn on the corner of today's South Bayshore Drive and MacFarlane Road.

THE CHURCH IN THE WILDWOOD. In 1891, eighteen Grove men came together to build the Union Chapel on land donated by Ralph Munroe, next to the present Coconut Grove Library. It later became Union Congregational Church. Kebo residents also worshipped there until they established a church of their own, St. Agnes Baptist, on what is now Thomas Avenue. (MCHMSF.)

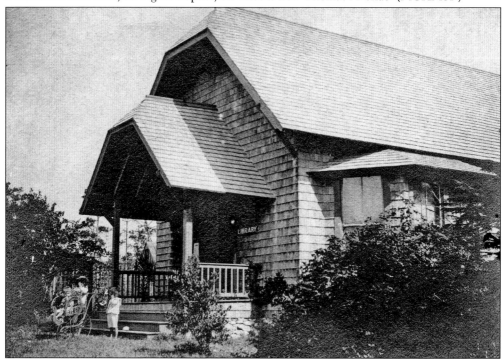

A LOVE OF BOOKS. Coconut Grove got its first library building in 1901 with funds donated by Kirk Munroe and land provided by Ralph Munroe. The Coconut Grove Exchange Library organized in 1895 following its founding by the Pine Needles Club. A replica of the original building is part of the current library. (MFCUM.)

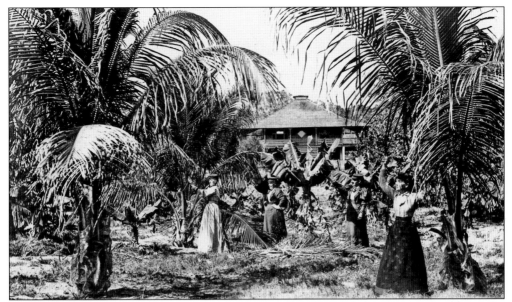

HOLD THAT POSE. Ralph Munroe loved photography, and his friends are shown here posing by the palm trees with arms in the air imitating the fronds. Munroe's home, the Barnacle, can be seen in the background. It was not a typical pioneer dwelling. Munroe designed a unique, square, hipped roof structure with one point of the square pointing due north, one due south, one east, and one west. Built high off the ground to discourage termites and other insects, the house added a distinctive new shape to the waterfront. (MCHMSF.)

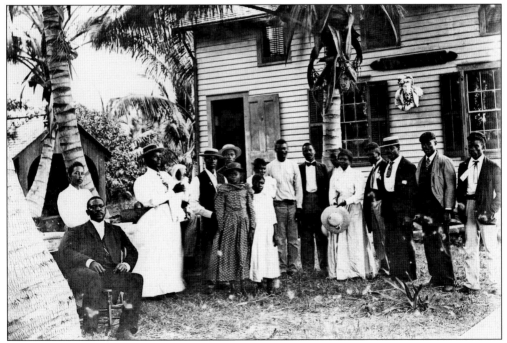

SUNDAY BEST. The entire Kebo community gathered for this historic photograph taken in front of Ralph Munroe's boathouse. The first families came from the Bahamas and worked at the Peacock Inn. Mariah Brown, the first to come, is the elegant woman holding the baby. (MCHMSF.)

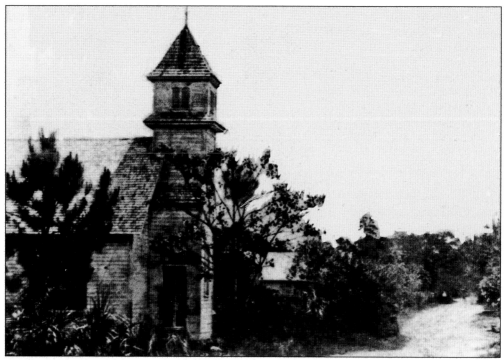

A STREET OF CHURCHES. Early Bahamian pioneer Rev. Samuel Sampson organized St. Agnes Baptist Church in 1895 on today's Thomas Avenue. The congregation later moved to Evangelist Street (Charles Avenue) and became Macedonia Baptist Church. It was not only the first black institution in South Florida but also the first Baptist church. (KSD.)

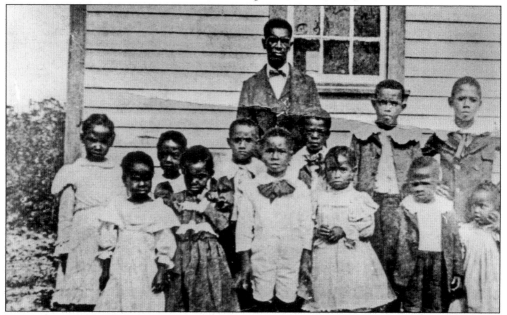

EDUCATION MATTERS. In 1900, Rev. John Davis opened a school in St. Paul's African Methodist Episcopal Church on Evangelist Street. Many of the first students were the children of the earliest pioneer families. (KSD.)

STRIKING A POSE. Nat Sampson and Alice Burrows dressed up to have their picture taken. Nat was Rev. Samuel Sampson's brother. He and Alice both worked at the Peacock Store. Alice Burrows's house still stands on Charles Avenue. (MCHMSF.)

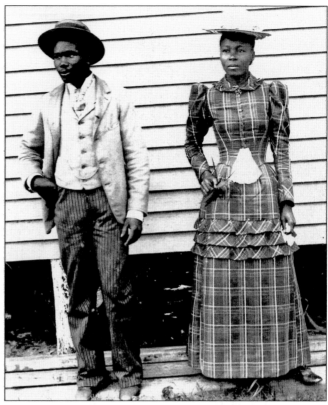

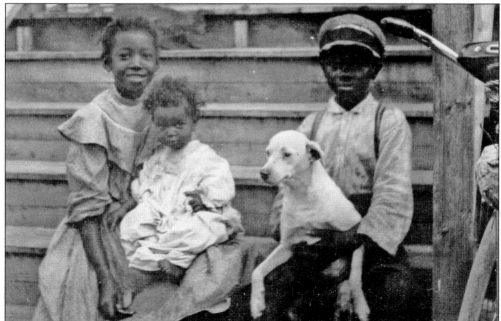

WAITING TO PLAY. These children patiently sat on the steps of the Peacock Inn to have their photograph taken. The puppy is trying to be as patient as the children, though something has caught his eye. (MFCUM.)

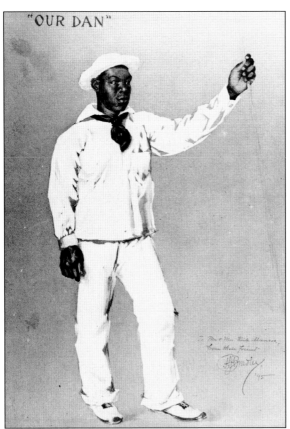

"OUR DAN"

OUR DAN. Dan Anderson came from the Bahamas and worked for Kirk and Mary Barr Munroe. He and his wife, Catherine, were very close to the Munroe family, who helped them build their home in Kebo. One of the Munroe's visitors drew this picture that is now in the possession of Thelma Anderson Gibson, Dan Anderson's granddaughter. (TAG.)

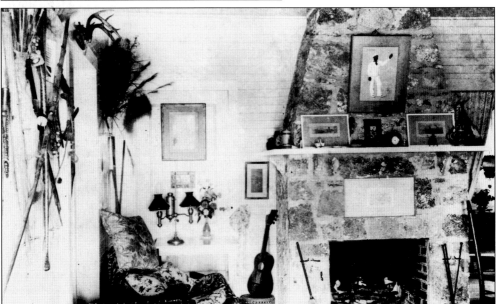

WORLD TRAVELER. Kirk Munroe traveled the world seeking inspiration for his novels. This rare interior view of his home that he and Mary named the Scrububs shows his collection of souvenirs. Dan Anderson's portrait hangs over the fireplace. (Library of Congress.)

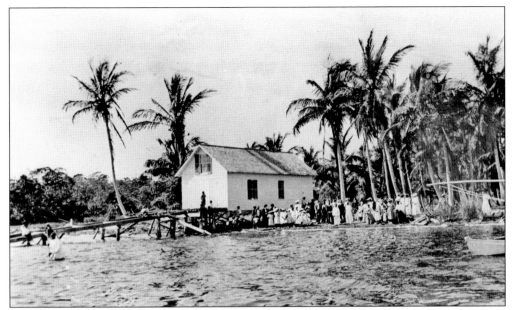

IMMERSED IN THE FAITH. Kebo residents often gathered in front of the Barnacle to perform baptisms in the bay. Despite segregation, Coconut Grove's pioneer black and white communities were unusually close. (MFCUM.)

THE PEACOCK INN. As more tourists came to Coconut Grove, Charles and Isabella Peacock built a larger building they called the Peacock Inn. It grew from the two-story Bay View House with a wide veranda into a complex of buildings. The inn later became a boys' school and was torn down in 1925. Today's Peacock Park occupies the site. (MCHMSF.)

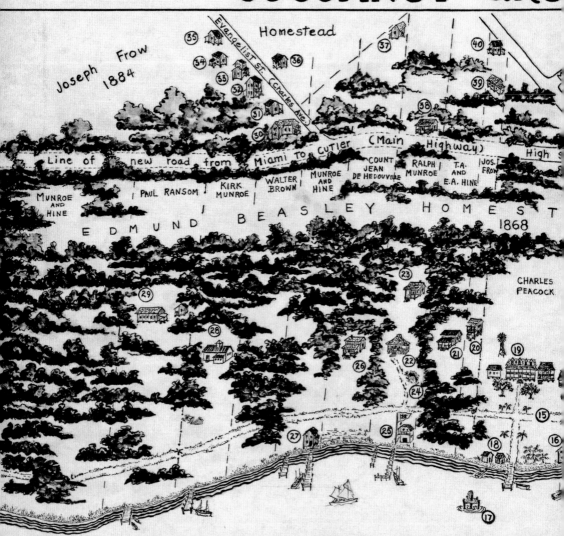

"COCOANUT" GRO

Homestead

Joseph Frow 1884

Evangelist St. (Charles Ave.)

35 34 36 37 40 33 39 52 38 31 30

Line of new road from Miami To Cutler (Main Highway) High

COUNT JEAN DE HEDOUVILLE · RALPH MUNROE · T.A. AND E.A. HINE · JOS. FROW

MUNROE AND HINE · KIRK MUNROE · WALTER BROWN · MUNROE AND HINE

PAUL RANSOM

MUNROE AND HINE

E D M U N D B E A S L E Y H O M E S T
1868

CHARLES PEACOCK

29 28 23 26 22 24 21 20 19 27 25 18 16 15

17

B I S C A Y N

① PENT RESIDENCE	⑤ SHONE RESIDENCE	⑩ EVA H. MUNROE GRAVE	⑮ COMMUNITY TRAIL	⑳ JOS. FROW RESIDENCE	㉕
② ROBERT'S FISH AND SPONGE MARKET	⑥ CARNEY RESIDENCE	⑪ UNION CHAPEL	⑯ CASINO	㉑ T.A. + E.A. HINE RESIDENCE	㉖
③ ARCHER RESIDENCE	⑦ ALBURY RESIDENCE	⑫ C.J. PEACOCK RESIDENCE	⑰ FRESH WATER SPRING	㉒ R. MUNROE "BARNACLE"	
④ C.H. PERRY RESIDENCE	⑧ HOUSEKEEPERS CLUB	⑬ SCHOOLHOUSE (1889-1894)	⑱ BATH HOUSES	㉓ "THREE SISTERS" HOUSE	㉗
	⑨ CHAS. PEACOCK STORE, P.O. AND EXCHANGE LIBRARY	⑭ McCORMICK RESIDENCE	⑲ BAY VIEW HOUSE (PEACOCK INN)	㉔ BEASLEY'S WELL	㉘

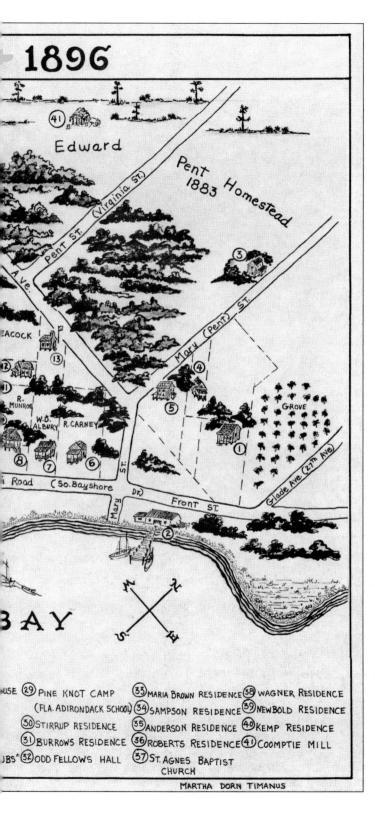

1896

Edward

Pent Homestead 1883

Pent St. (Virginia St.)

Mary (Pent) St.

Ave.

EACOCK

R. MUNROE

W.O. ALBURY R. CARNEY

Road (So. Bayshore

Mary Dr.

Front St.

Glade Ave. (27th Ave.)

GROVE

BAY

USE ㉙ PINE KNOT CAMP
(FLA. ADIRONDACK SCHOOL)

㉚ STIRRUP RESIDENCE

㉛ BURROWS RESIDENCE

JBS" ㉜ ODD FELLOWS HALL

㉝ MARIA BROWN RESIDENCE

㉞ SAMPSON RESIDENCE

㉟ ANDERSON RESIDENCE

㊱ ROBERTS RESIDENCE

㊲ ST. AGNES BAPTIST CHURCH

㊳ WAGNER RESIDENCE

㊴ NEWBOLD RESIDENCE

㊵ KEMP RESIDENCE

㊶ COOMPTIE MILL

MARTHA DORN TIMANUS

"COCOANUT GROVE" 1896. Before the City of Miami was born in 1896, Coconut Grove was known as the largest and most influential community in the area. This map, drawn by artist Martha Dorn Timanus during the Grove's 1973 Centennial, documents that era.

33

A CARING HEART. Harriet Parsons James, wife of Arthur Curtiss James, one of the richest men in America, wintered with her husband at their estate, Four Way Lodge, on today's Poinciana Avenue. She was active in the community, founding the local Red Cross, funding the construction of Plymouth Congregational Church, and aiding the black community. (FMC.)

Three

THE SWELLS AND MILLIONAIRE'S ROW

From the time of its second incarnation, Coconut Grove was blessed with a remarkable group of residents and visitors. Beginning with the Peacocks and Ralph Munroe, the nascent community quickly attracted a variety of individuals who gave it a kind of sophistication unknown on other frontiers. The locals called them Swells, but for the most part, these wealthy, educated residents did not live apart from community affairs.

Ralph Munroe brought in the first group of Swells, but as word spread, others soon followed. Author Kirk Munroe added the literary crowd—publishers, poets, preachers, authors, and artists. Paul Ransom's school attracted the children of the eastern establishment, and many of their parents built winter homes nearby.

Besides the two Munroes, the most influential residents were the two Williams—William Matheson and William Deering. By 1902, both had built winter homes in Coconut Grove. William Matheson invited his friend Arthur Curtiss James, the sixth richest man in America, to stay in his home, Four Way Lodge. James and his wife, Harriett, soon bought the house and wintered there the rest of their lives. Both of the Deering sons left their mark—James with what is now Vizcaya Museum and Gardens and Charles with estates in Buena Vista and Cutler.

As Vizcaya's fame spread, other international luminaries and giants of industry soon followed, and the bay front filled with beautiful estates and gentlemen's cottages. Many Kebo residents worked in the bay-front mansions and built close relationships with their millionaire owners. Sometimes they lived on the premises and took charge of the estates in the owner's absence. Bahamian mariners captained and became crew on the ever-increasing number of yachts that filled the newly dredged canals and harbors.

While the men hung out at the exclusive Biscayne Bay Yacht Club, their wives joined the Housekeeper's Club and mingled with local women whose husbands might be fishermen and laborers, as well as professionals. They participated in the club's efforts to better both the black and white communities and, when called upon, held benefits and gave money to institutions like libraries, a variety of churches, and the schools.

These early relationships between the Swells and the less affluent residents stamped Coconut Grove with a live-and-let-live philosophy and tolerance for eccentricities that survives today.

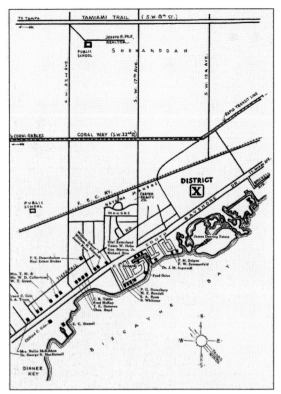

MILLIONAIRE'S ROW. In 1932, Frank F. Stearns published *Along Greater Miami's SUN-SEA-ARA*. It provided an incredible snapshot of a long gone era when the mostly winter homes of wealthy and prominent people dominated the Coconut Grove waterfront. Many of the mansions survived into the 1960s. Today few remain.

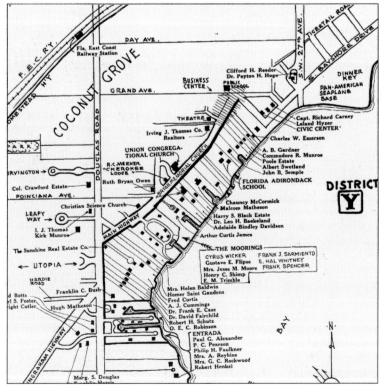

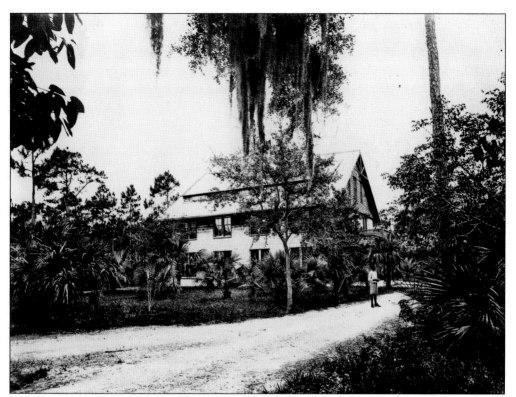

WALDEN SOUTH. After the Peacock Inn closed in 1902, Ralph Munroe opened Camp Biscayne 250 feet south of the Barnacle so that those who came to the Peacock Inn would have another unique place to winter in the Grove. With a nod to Henry David Thoreau, Munroe built a group of wooden cottages nestled in the hammock near a large main lodge. He preserved as much of the hammock as possible because he believed that it had "worked out its life's problems and established itself as the legitimate occupant of the land." Later many Camp Biscayne visitors built winter homes in Coconut Grove. Today the site is a walled subdivision called Camp Biscayne. (MCHMSF.)

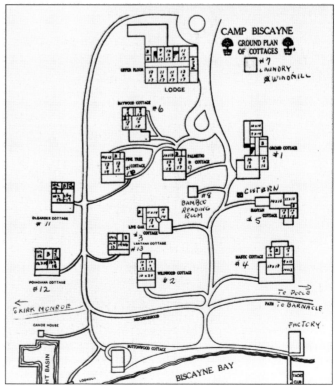

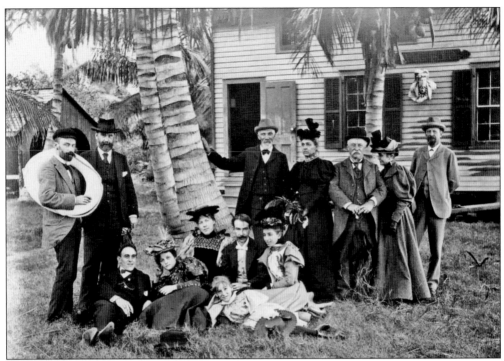

AFTERNOON TEA. Often Coconut Grove's resident and visiting Swells would gather at the Barnacle for a relaxing afternoon tea. (MCHMSF.)

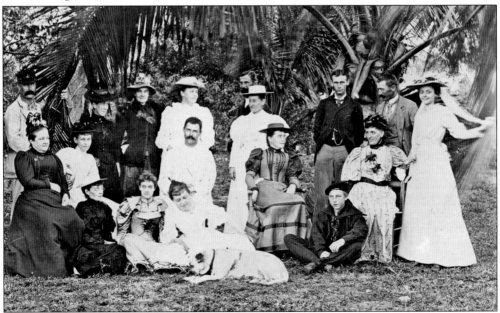

ON THE MIAMI RIVER. The Swells also had tea at Julia Tuttle's home on the Miami River. Tuttle, center (looking right and wearing a white dress), bought 644 acres on the north bank in 1891 and planned to build a new city there. When this picture was taken, around 1892, her vision was still little more than a dream. Isabella Peacock is seated on the left and Flora MacFarlane on the right. (MCHMSF.)

An Enduring Legacy. Few, if any, families can match the contributions of the Mathesons, who gave the county both Matheson Hammock and Crandon Parks. But it was Coconut Grove that attracted family patriarch William John Matheson to South Florida in the first place. A creative scientist, who made his fortune in the chemical industry, Matheson arrived on his boat in the early 1900s to visit his sons Hugh and Malcolm, who boarded at the Florida-Adirondack School (now Ransom-Everglades). "I don't suppose anyone," Marjory Stoneman Douglas wrote, "loved Coconut Grove and Key Biscayne better than W. J. Matheson." (FMC.)

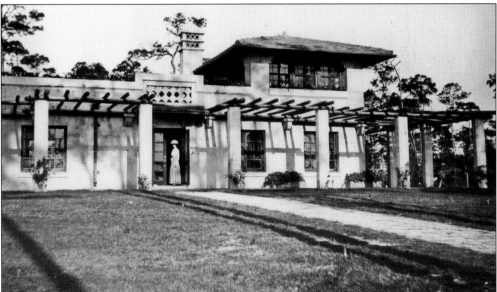

Four Way Lodge. In 1905, William Matheson brought in his northern architect, Robert W. Gardner, to design his first home in the Grove on a 20-acre site that became today's Poinciana Avenue. Kirk Munroe suggested he name the estate Four Way Lodge after a lodge in a Rudyard Kipling poem because it was accessible from all directions. Matheson sold it to Arthur Curtiss James in 1913. The Jameses lived in the home until their death in 1941. Four Way Lodge has been demolished, but the servant's quarters remain as a private home.

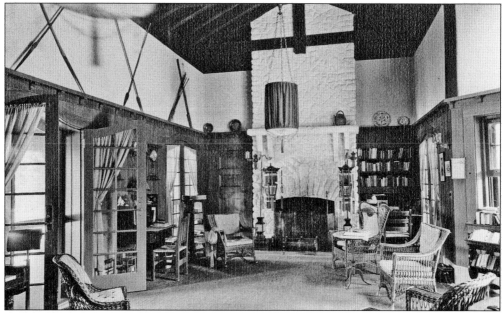

A Tropical Paradise. William Matheson's second home was named Swastika Lodge. (Until Adolph Hitler adopted the swastika as a Nazi symbol, it had been used for thousands of years as a symbol of the sun.) It faced Biscayne Bay off today's Main Highway. This rare interior view highlights items Matheson collected on his world travels. Although altered, fragments of the home remain today on the Duchesne Campus of Carrollton School of the Sacred Heart. (FMC.)

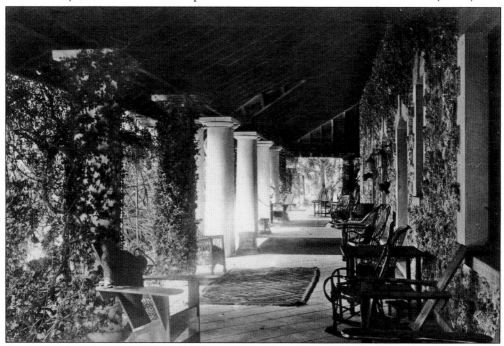

Catching the Breeze. William Matheson knew how to take advantage of Coconut Grove's unique environment. Swastika Lodge had a wide, bay-side veranda overlooking a boat basin and canal. The grounds featured many of the tropical plants that interested him. (FMC.)

FINDING TREASURE. In 1912, Chicagoan Ernest C. Cole purchased a large tract of land that spread from today's Tigertail Avenue to Biscayne Bay. During construction of his winter home, workers unearthed the remains of a ship, anchor chain, and 2.5 pounds of melted coins and metal. This discovery prompted a series of articles about the possibility that Cole had unearthed pirate's gold. In response, he named his home Treasure Trove. (McN.)

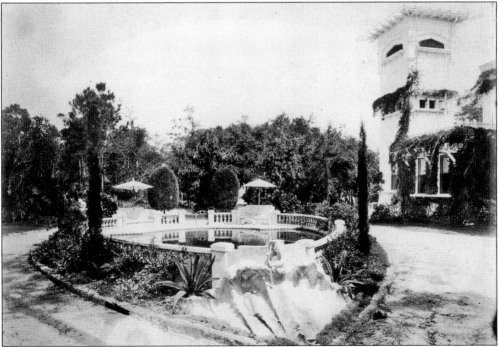

TROPICAL EDEN. E. C. Cole collected plants from around the world to landscape his estate, which was famous for its row of royal palms that flanked the entrance from South Bayshore Drive. The grounds also included a variety of sculptures he created. His heart-shaped swimming pool was just one of the property's unique features, as was the model of a cliff-dweller's settlement. Today a subdivision named Treasure Trove occupies the site. (McN.)

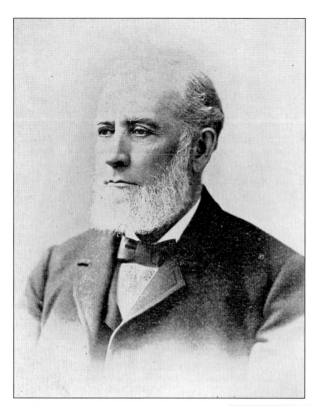

A Providential Move. In 1902, the Deering Harvester Company that manufactured agricultural machinery and was founded by William Deering merged with the McCormick Harvesting Machine Company, ultimately creating International Harvester. Soon thereafter, William and his wife, Clara, purchased a plot of land on today's Royal Road and built a modest winter home. Their sons, Charles and James, visited them in the Grove and also became enchanted with the area. Charles built two South Florida estates—one in Buena Vista and a second in Cutler. James built Vizcaya, a national landmark.

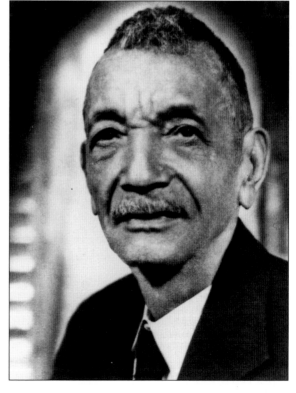

A Born Leader. William Deering hired E. W. F. Stirrup, a native of Harbour Island, Bahamas, to work for him in Coconut Grove. Stirrup moved to today's Charles Avenue and, in 1897, built a large home there. He became the largest landowner in today's Village West. He also built the Charlotte Jane Cemetery in honor of his wife. The Stirrup home remains as a monument to the early Bahamian families who gave the Village West its distinctive character. (KSD.)

A Man with a Vision. In 1912, William Deering's son James purchased more than 100 acres of virgin hammock land from Mary Brickell, where he planned to build a winter home. He had recently ceased to be involved in International Harvester and had time on his hands to travel. He hired architect F. Burrell Hoffman and interior designer Paul Chalfin to create his masterpiece, which he named Villa Vizcaya. (Vizcaya Museum and Gardens.)

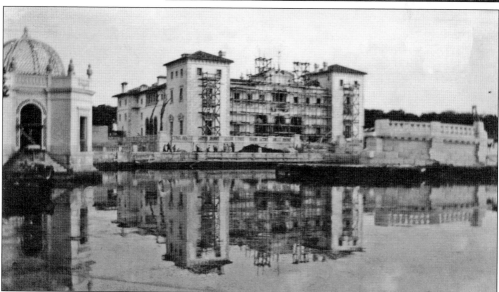

Reflections of Grandeur. By early 1916, James Deering's home was rising on Biscayne Bay. Alice Wood, Miami's first female photographer, captured Vizcaya shortly before its December 1916 grand opening.

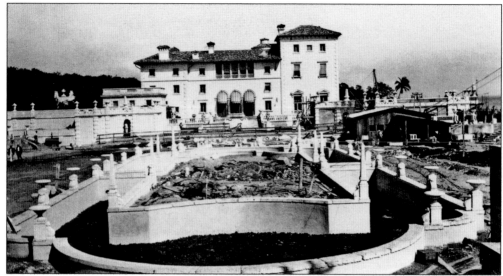

GARDENS ON THE BAY. Alice Wood also recorded the construction of Vizcaya's gardens, designed by Diego Suarez. Suarez merged Italian formal garden design into a tropical setting. Sculpture and architectural features acquired on frequent trips to Italy became focal points in the gardens that were completed in 1922.

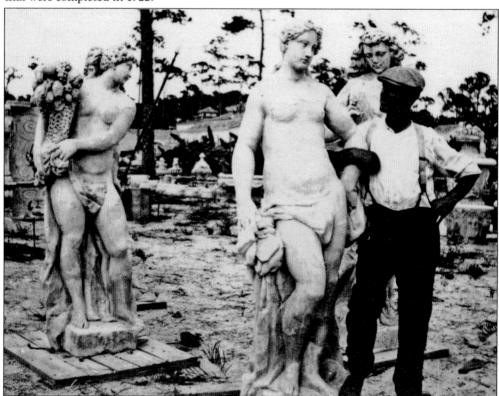

A WORKER'S DREAM. James Deering hired thousands of local workers, including many of the men from Kebo. Alice Wood captured one posing with a marble statue that would be incorporated into the garden.

A New Style. In 1917, John Bindley, president of Pittsburgh Steel, commissioned the Pittsburgh firm of Kiehnel and Elliott to design a palatial winter home for him on a 10-acre track of Coconut Grove bay front. This estate, named El Jardin, launched Richard Kiehnel's architectural career in Miami and influenced other architects to adapt the style that became known as the Mediterranean. Bindley opened his home for community events, including the Housekeeper's Club's yearly extravaganza, which raised money for its projects. The sponsors of this 1923 Grecian-themed event at El Jardin read like a who's who.

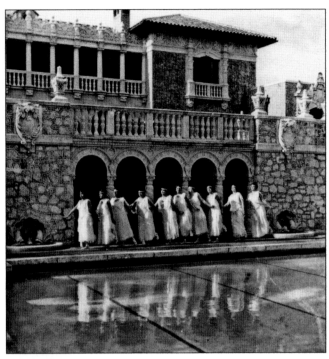

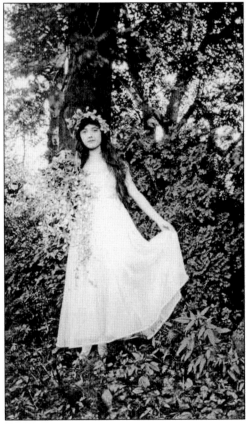

A Vision of Loveliness. Beautiful Eunice Isabella Peacock, granddaughter of Isabella and Charles and future wife of Coral Gables developer George Merrick, participated in the Housekeeper's Club benefits at El Jardin. (GS.)

45

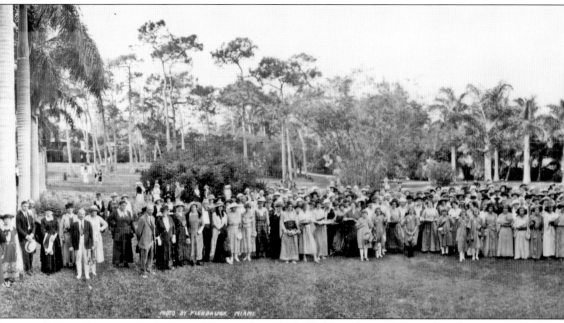

Party Panoramas. Pioneer photographer W. A. Fishbaugh was famous for what were called "Cirkut" photographs. The moving camera produced the impressive, almost yard-long views. The expansive, royal palm-framed front lawn of the James Estate was one of Fishbaugh's favorite

Hold Still and Watch the Moving Camera. Fishbaugh also took "Cirkut" photographs of visiting conventioneers who had discovered Miami. This group of travel executives enjoyed the

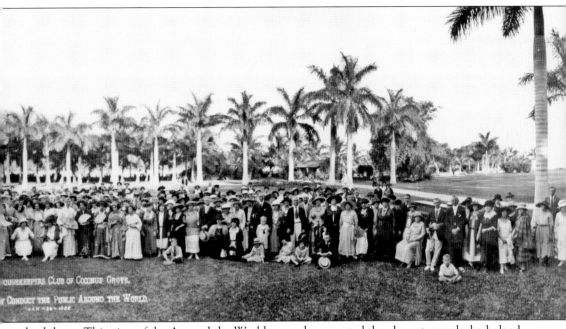

backdrops. This view of the Around the World event documented the elegant crowd who helped raise $2,000 to pay off the Housekeeper's Club mortgage on their new clubhouse. (SPA.)

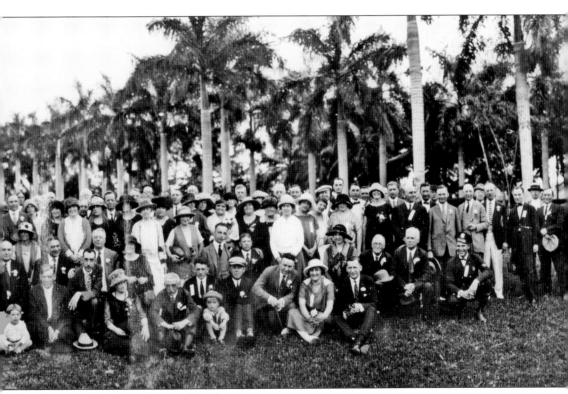

ambiance of the James Estate. (SPA.)

THE GREAT COMMONER. William Jennings Bryan was another famous Coconut Grove resident. In 1913, he and his wife, Mary, built their home, Villa Serena, on the Brickell Avenue bay front just east of soon-to-be-built Vizcaya. Famous for being a three-time presidential nominee for the Democratic Party and secretary of state under Woodrow Wilson, Bryan also taught a popular Sunday school class in Royal Palm Park. His home still stands today and is undergoing restoration. (SPA.)

THE ANCHORAGE. In 1924, the Bryans purchased L. H. Huntington's estate, The Anchorage, and renamed it Marymount. They subdivided the property and sold the Main Highway section to the Methodist Church, now the Chabad of South Dade. After Bryan's death, Mary sold the home to renowned scientist L. H. Baekeland, inventor of Bakelite, the forerunner of plastic. In this early 1930s view, members of the Baekeland family enjoy a winter sojourn in Coconut Grove. From left to right are daughter-in-law Cornelia Middlebrook Baekeland; L. H. Baekeland; his wife, Céline, and daughter Nina Baekeland Roll. Although much of the property has been subdivided into a gated community called The Anchorage, the original home has been restored and the grounds beautified. (Baekeland Family Archives.)

MAKING HISTORY. Ruth Bryan Owen, William and Mary Bryan's daughter, lived on Main Highway in her home, Chota Khoti. In 1929, she became the first Florida woman elected to the U.S. House of Representatives. She also became the nation's first female ambassador after Pres. Franklin Delano Roosevelt named her ambassador to Denmark. She ended her public career as a delegate to the committee that created the United Nations. (Leona Sangster.)

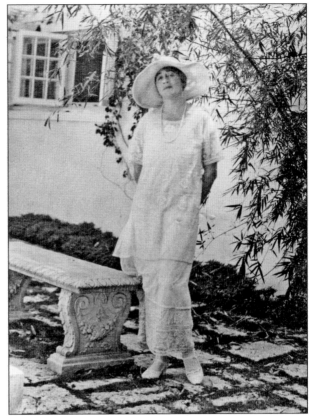

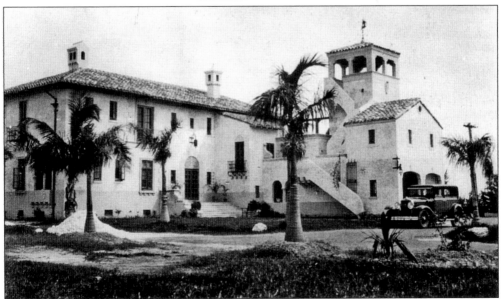

A FAMILY AFFAIR. In 1922, E. C. Cole's son Clifford built the Walter DeGarmo designed Villa Mira Mare on the bay front. During the 1926 hurricane, the Cole family survived the worst of the storm in the tower. The home was later owned by George and Dorothy Engle, founders of the Coconut Grove Playhouse, who sold it to the new Coral Reef Yacht Club in 1955. (McN.)

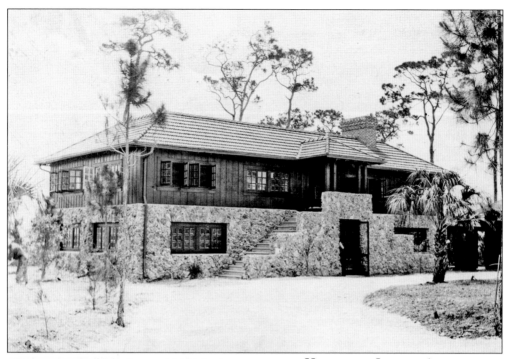

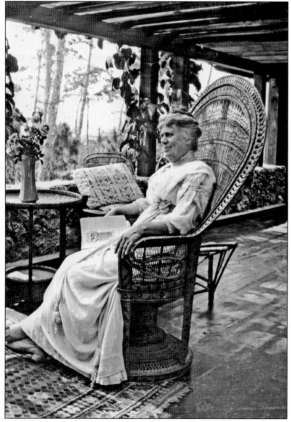

HONORING A LEGEND. August Saint-Gaudens was one of America's most famous sculptors. Today his Cornish, New Hampshire, home is a national landmark. Following his 1907 death, his widow Augusta built a winter home in Coconut Grove on Ozone Avenue. After her death, her son Homer wintered there for many years. (DC.)

CATCHING THE BREEZE. Augusta Saint-Gaudens relaxes on the porch of her Coconut Grove home. Ozone Avenue was later renamed St. Gaudens Road in honor of the famous family. Willis duPont demolished the home in the early 1960s and built a large mansion on the site. (DC.)

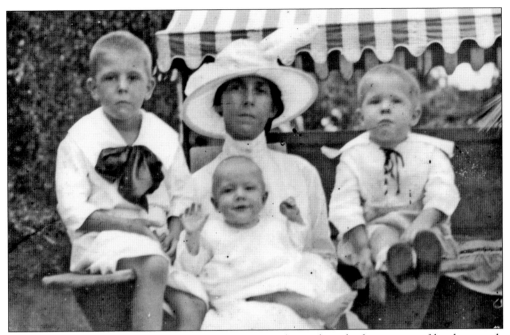

Leaving Their Mark. William Matheson's son Hugh purchased a large tract of land in south Coconut Grove, where he built two homes for his family and a subdivision he named Entrada. Their first home, Villa Liguori, was named in honor of his wife, seen here with three of their four sons, from left to right, William, Hugh Jr., and Finlay L. Several of Hugh and Liguori's grandchildren and great-grandchildren remain in South Florida. (FMC.)

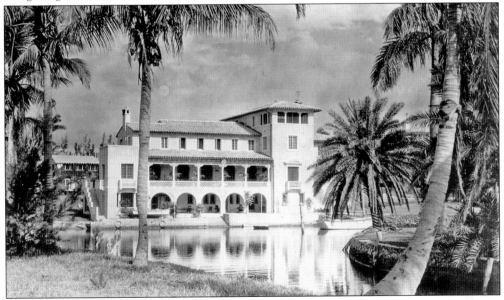

Entrada. Hugh Matheson's Entrada encompassed 20 acres of land around today's Matheson Avenue. It included more than 27 home sites, most of which fronted man-made canals and a large yacht basin. Matheson hired landscape architect L. LaTrobe-Bateman to design the grounds. Matheson's own home, seen here, was the focal point of the new subdivision. The mansion remains today, but the grounds have been re-subdivided into additional lots. (FMC.)

COCONUT GROVE
LAYS ITS CARDS ON THE TABLE!!

What Price--Freedom?

What Price--Freedom?

Some mis-informed Miami people say that annexation will be beneficial to Coconut Grove because it will give Police, Fire and Sanitary protection to us. This is a joke, for we already have more Policemen, more Firemen and Better Fire Apparatus, more Men and more Equipment in our Sanitary department in proportion to our population than Miami is likely to ever have.

Some people say that Miami can carry forward the work after annexation. We answer that by asking "HOW IN THE WORLD can Miami City officials take care of the mass of detail necessary to carry out our plans when they are already swamped with work as evidenced by the lack of improvements on many miles of streets in the present city of Miami?" What about the condition of Miami's inadequate garbage collection, of its floods of water standing after each rain, of its traffic congestion?

We Are Opposed To Annexation To Miami!
Because:

Out of months of hard work, a real program of improvement for Coconut Grove has been laid out. WE HAVE AMPLE FUNDS TO PAY FOR THESE IMPROVEMENTS. We want to remain separate and distinct from affiliation with Miami until we can get our improvements completed.

Coconut Grove is being forced into Miami against its will by the use of an unfair law in this election, that was passed twenty years ago and which

has never been used in any election in this entire State as far as we have been able to learn. This law reads that in an annexation election if two-third of all the votes cast in the entire territory are in favor of annexation, the cities are then joined. NOT—mind you—two-thirds of the votes in Coconut Grove, but two-thirds of ALL the votes cast in Miami and in the territory to be annexed.

COCONUT GROVE has not more than 240 voters, against possibly 3,000 in Miami.

What Chance Do We Have?

Not a chance, unless our good Miami friends, who believe in fair and square dealing, will go to the polls next Wednesday, September 2nd, and

June 16-1925
CNB City Commissioners
Mayor H. D. B. Justison
H. M. Mathieson
Dr. E. W Ayars
Stephen H. Crawfor
George L. Reynolds
George D. Emerson
Dr. G. C. Franklin
A. L. Hardie

VOTE NO!!

On the Annexation Question!

We are building a complete new waterworks with all new large mains and pumps in accordance with Fire Underwriters Regulations, and if we are let alone we will finish our water softening plant in a short while, providing pure, soft and palatable water.

The problems of Coconut Grove are not the problems of Miami. We want to solve our own problems in our own way.

We have on hand the necessary money to build an adequate City Hall that will be a credit to this section and if we are let alone we can build this beautiful structure.

We have the money on hand to re-pave and rebuild our streets and if we are let alone, we will finish the job.

We have the money on hand to provide parks and playgrounds for children, and if we are let alone we will soon finish these projects.

We have received donations of extremely valuable land for street widening purposes, and if we are let alone we will carry through these projects.

This Advertising Sponsored by a Group of Prominent Citizens of Coconut Grove

A SAD DAY. Coconut Grove was incorporated as a municipality in 1919. The young town enjoyed that status until September 1925 when the rapacious City of Miami annexed it against its will. Trying to stop the inevitable, the town ran full-page advertisements in local newspapers asking people to vote "NO."

Four

TOWN OF

COCONUT GROVE

Coconut Grove residents have never forgiven the City of Miami for annexing them on that rainy September day in 1925. Even today residents seek ways to de-annex themselves from the frequently maligned City of Miami. Adding to their discontent is the belief that the election was stolen and purposely held when most of the Grove residents were away. That is not true, and even if it were, it would not have mattered. The election was structured to let a majority of all voters in the City of Miami and the areas proposed for annexation—Coconut Grove, Allapattah, Little River, Lemon City, Silver Bluff, and Buena Vista decide. When the final vote was tallied, the only electors who predominately voted "no" lived in Coconut Grove.

At the time of annexation, Coconut Grove had only been incorporated for six years. In 1919, spurred by fear of a continuation of the Dinner Key Naval Air Station, residents met at the Coconut Grove School and voted to incorporate. Ironically, during that six-year period, the unique character of the Grove was threatened by the action of the town council. In July 1920, the new council hired renowned Philadelphia architect John Irwin Bright to do a town plan, and when completed, they voted unanimously to implement it.

If they had succeeded, the plan would have transformed Coconut Grove into a combination of Palm Beach and Coral Gables with ornate Spanish-Mediterranean-style buildings, grand boulevards, a mirror lake, hotels, theaters, automobile showrooms, and a golf course. The most startling proposal was to move what was then called "colored town" north of today's Dixie Highway and west of Douglas Road and transform the former black community into a golf course. (Although shocking by today's standards, the plan promised that the new community would have "the same quality of design" as the larger white area.) It included an impressive Mediterranean-style town center with a theater, shops, schools, and a woman's club that was complete with a day care center.

The town plan for Coconut Grove did have some bright ideas, including a green buffer around the town to protect it from unwanted development. But to any unreconstructed Groveophile, it would have destroyed the Grove's unique character that—despite future, equally bad plans—has survived battered but intact.

HISTORIC TREES. In 1919, the new Town of Coconut Grove adopted a city seal that highlighted the two coconut trees that stood on the Coconut Grove bay front when the "Cocoanut Grove" post office was reopened in 1884. They also dropped the "a" from coconut.

MAKING HISTORY. Coconut Grove residents created a mayor–alderman form of government and elected realtor Irving J. Thomas their first mayor. (ECO.)

54

A Proud Legacy. Hugh Matheson (pictured) became Coconut Grove's third mayor. Following his father's legacy, son Hardy later served on the Dade County Commission, and other members of the Matheson family remain involved in community affairs. (MFC.)

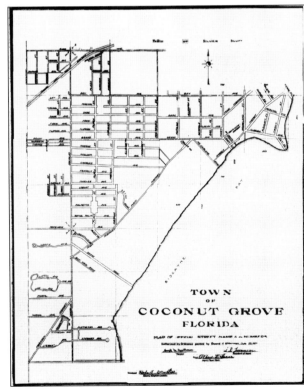

The Original Boundaries. Today Coconut Grove has rather loose boundaries and includes the former town of Silver Bluff and the subdivisions surrounding Vizcaya. The official map of the Town of Coconut Grove encompassed a smaller area within its corporate limits. (John Nordt.)

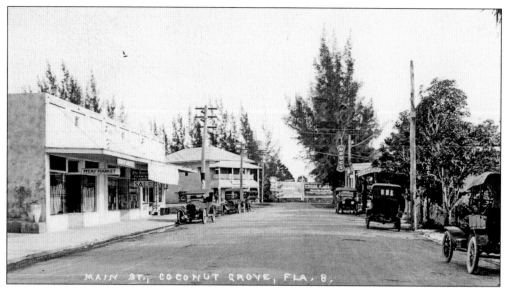

DOWNTOWN. Coconut Grove's main street was Ingraham Highway, popularly known as Main Highway. The buildings on the left were built by the Sunshine Fruit Company and, although altered, remain today. In the distance is the Sanders-Peacock store, now the site of CocoWalk. On the right behind the trees is the recently demolished St. Stephen's Church.

REMEMBERING FLORA. In 1920, members of the Housekeeper's Club convinced the town leaders to allow them to construct a memorial to their late founder, Flora MacFarlane. It stood at the foot of MacFarlane Road on the bay front. The 1926 hurricane destroyed it, and it was never rebuilt.

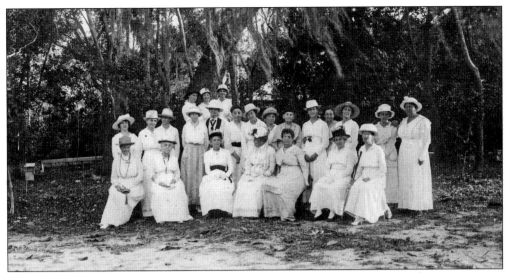

AN HISTORIC DAY. Members of the Housekeeper's Club posed for this historic picture the day they moved from their old wooden clubhouse to their grand new home on South Bayshore Drive. The group included some of Coconut Grove's earliest residents. (WCCG.)

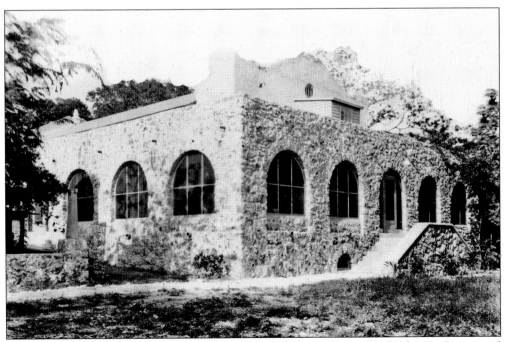

SOLID AS A ROCK. The Housekeeper's Club's new clubhouse, designed by Walter DeGarmo and completed in 1921, remains today in its original location. Now known as the Women's Club of Coconut Grove, it has recently undergone a complete restoration and is one of Coconut Grove's most important landmarks.

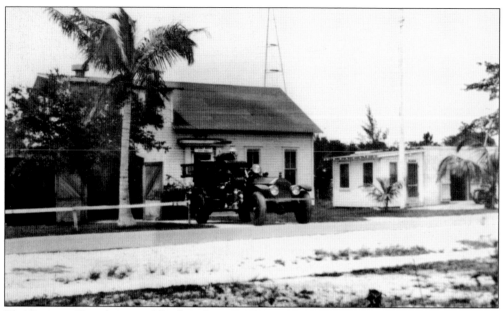

THE SEAT OF GOVERNMENT. The first Coconut Grove Town Hall was in Irving J. Thomas's real estate office at the foot of Mary Street. It later moved to Dade Avenue, now Oak Avenue, where the Coconut Grove Fire Department also had a facility. (R.)

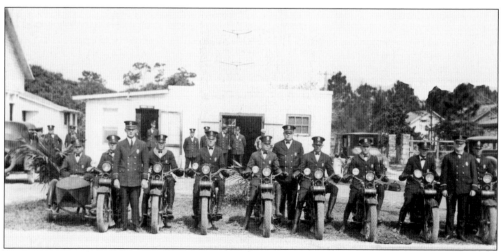

MOTOR MEN. The Coconut Grove police department was proud of its motorcycle corps. Police headquarters were part of the Oak Avenue municipal complex. (R.)

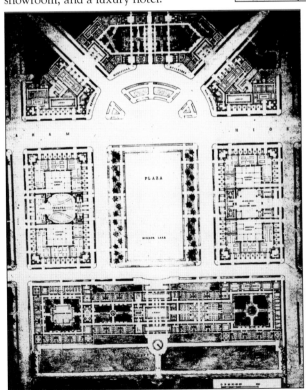

THE BRIGHT PLAN THAT WASN'T. In 1921, Philadelphia architect John Irwin Bright completed a comprehensive plan for the new town that, if implemented, would have transformed Main Highway into a four-lane boulevard. (Only one section was completed at the Moorings.) MacFarlane Road became a mirror lake reflecting a grand city hall near the site of CocoWalk. Other new buildings included theaters, an automobile showroom, and a luxury hotel.

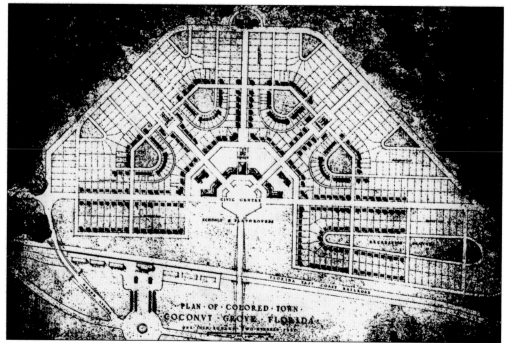

GOODBYE KEBO. The Bright Plan included plans for a "colored town" that moved the entire black community across today's Dixie Highway north of Metrorail. The plan included homes, schools, a day care center, parks, and churches.

THE COCONUT GROVE "COLORED SCHOOL." In 1924, George Merrick acquired a half-finished, new "colored school" west of Lejeune Road just south of Dixie Highway. In return, he donated a 5-acre campus and built a Coral Gables-style school that included grades kindergarten through 12. It was renamed George Washington Carver in 1943, following the scientist's death. Although often considered part of Coconut Grove, the school and the surrounding Golden Gate and MacFarlane Homestead property are in Coral Gables.

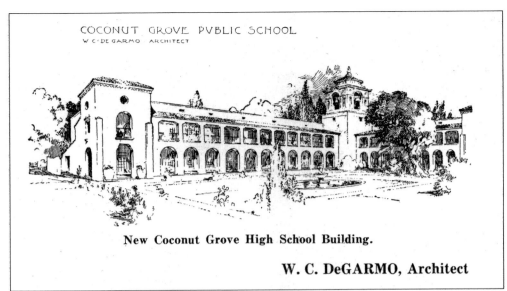

New Coconut Grove High School Building.

W. C. DeGARMO, Architect

COCONUT GROVE HIGH SCHOOL. The new Town of Coconut Grove wanted its own high school, so it convinced the Dade County School Board to add a high school wing to the elementary school. It was designed by renowned architect Walter DeGarmo. Completed in 1922, only one class (1925) completed three years of high school there. In April 1926, the high school closed, and students moved to the new Ponce de Leon Senior High School in Coral Gables. Today the high school wing, visible from Grand Avenue, is part of the elementary school. (ECO.)

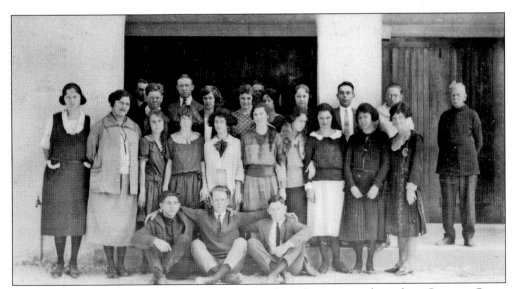

THE ONE AND ONLY. The proud class of 1925 was the only one to graduate from Coconut Grove High School. (William Shaddix.)

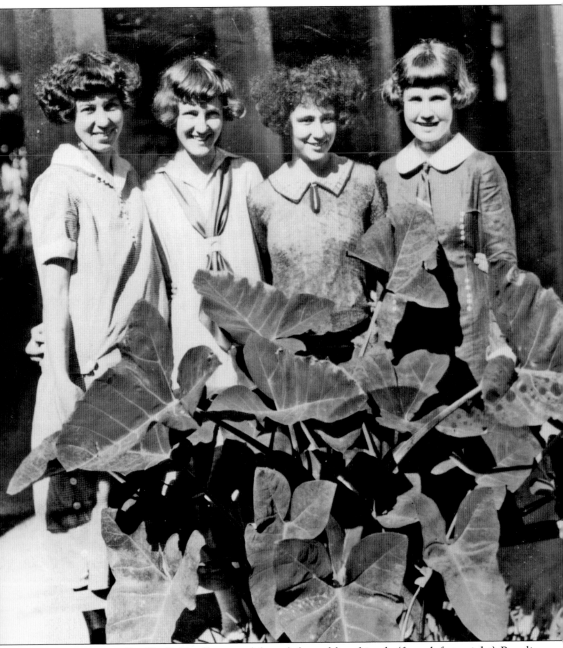

BEST FRIENDS. Estelle Caldwell, second from left, and her friends (from left to right) Rosalie Walker, Sylvia Rosenstock, and Mary Grace Clinton enjoy their days at Coconut Grove High School. Estelle went to work for realtor and first mayor Irving J. Thomas the day after graduation. A fount of Coconut Grove history, she died in 2009 at age 102. (ECO.)

THE SUNSHINE CORNER. The Sunshine Fruit Company, which sold real estate and managed area grapefruit groves, built this corner building designed by Kiehnel and Elliott. Although somewhat altered, the building survives on the intersection of Main Highway, MacFarlane Road, and Grand Avenue.

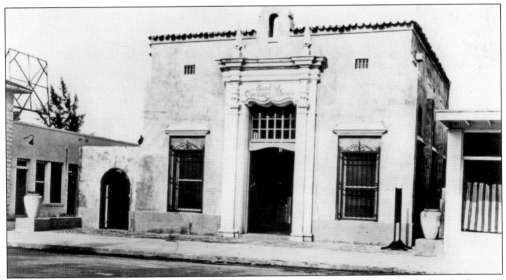

BANKING ON THE FUTURE. The beautiful Bank of Coconut Grove, designed by Walter DeGarmo, advertised that it followed the Bright Plan. The building still stands on the corner of Fuller Street and Main Highway.

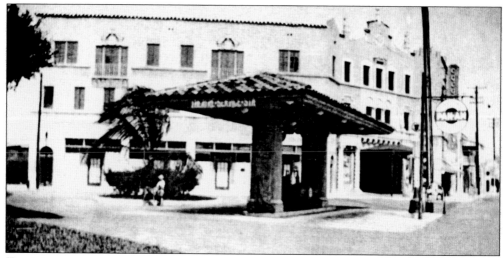

THE MOVIE PALACE. Irving J. Thomas and his partner, Fin J. Pierce, built the Coconut Grove Theatre on Main Highway and Charles Avenue. The January 1, 1927, opening night featured the D. W. Griffith's silent movie *The Sorrows of Satan*, starring Adolphe Menjou. A 12-piece orchestra enhanced the event, along with the sounds of the mighty Wurlitzer concert grand organ. Designed by Kiehnel and Elliot, it was the largest theater in Miami and one of the first to be air-conditioned. It cost almost half a million dollars to build in 1927. Besides the theater, the three-story building also housed apartments and retail shops. (ECO.)

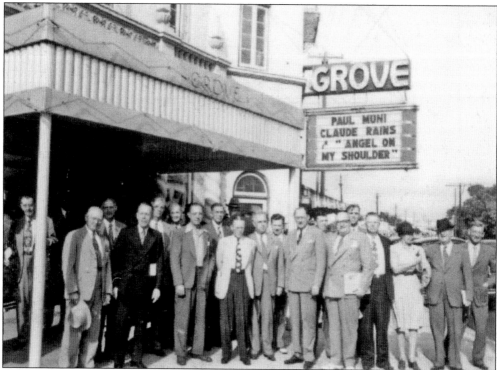

MOVING IMAGES. A group of dignitaries joined owners Irving Thomas and Fin Pierce at the opening of the 1946 classic *Angel on My Shoulder*, starring Paul Muni and Claude Rains. The legendary movie theater closed in the early 1950s. (R.)

64

THE END OF AN ERA. On September 10, 1925, a somber Coconut Grove council formally turned over the Town of Coconut Grove to the City of Miami. Still smarting from what many Coconut Grove residents consider a travesty, sporadic efforts to de-annex the Grove from the City of Miami continue today. (R.)

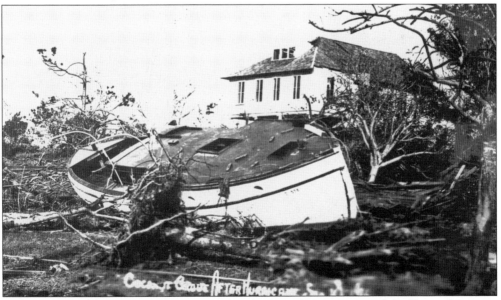

ANOTHER BLOW. A little more than a year after the City of Miami annexed the Town of Coconut Grove, the killer 1926 hurricane devastated the area. The waterfront community of Coconut Grove was particularly hard hit. The powerful storm surge inundated low-lying bay front properties and crashed hundreds of boats on front lawns and streets. On the bright side, the hurricane killed the boom of the 1920s that threatened Coconut Grove's unique identify and left it mostly intact until the next boom arrived decades later.

RAISING THE FLAG. Edward and Marie Swenson launched a dream that became Coconut Grove's Everglades School for Girls. Designed by Weed, John, and Russell on South Bayshore Drive and Emathla Street, the first students dedicated the new school on September 10, 1955. Everglades merged with Ransom in 1974, giving birth to the current Ransom-Everglades School. The original Everglades School for Girls is now the Ransom-Everglades Middle School.

Five

LIVING AND LEARNING

From the time of its founding, Coconut Grove has been defined by its quality of life. Beginning with Isabella Peacock's Sunday school and the founding of Miami's first public school, the Grove has a proud tradition of fostering intellectual, spiritual, and educational growth.

In addition to Isabella Peacock, early residents, like Flora MacFarlane, Kirk and Mary Barr Munroe, Ralph Munroe, Samuel Sampson, Jeremiah H. Butler, and Paul Ransom, sponsored religious and educational institutions that continue today. Later affluent residents, including William Matheson; William Deering and his son James; Arthur Curtiss James and his wife, Harriett; Jessie Moore; and William Jennings Bryan, provided funds to build churches even if they were not members.

Coconut Grove also claimed a particularly gifted group of learned women. Writers Mary Barr Munroe, Marjory Stoneman Douglas, Prunella Wood, and Helen Muir left an impressive body of work and provided leadership to a variety of causes. Female educators also left their mark. Frances Tucker, Kate Stirrup Dean, and Julia Harris are well remembered. Private institutions led by Marian Krutulis, Marie Swenson, and the Sisters of St. Joseph remain important educational centers. Miami's first female doctor, Eleanor Galt Simmons, also lived in Coconut Grove.

The close-knit community empowered leaders, including Rev. Canon Theodore R. Gibson who, from his Christ Church pulpit, fought for his community and led the civil rights movement that changed the course of history. His wife, Thelma Anderson Gibson, whose ancestors attended the first black school on Charles Avenue, continues his legacy today through the Theodore R. Gibson Memorial Fund and her own community involvement.

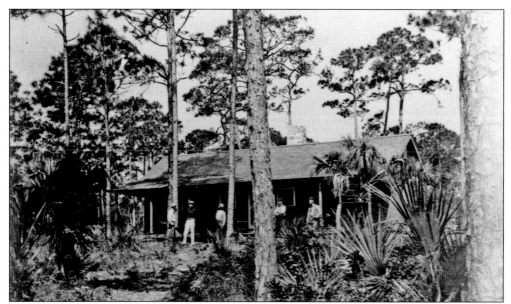

AN EDUCATIONAL PIONEER. In 1893, New Yorker Paul C. Ransom discovered Coconut Grove. Three years later, he opened Pine Knot Camp for boys on the same site as the upper school of today's Ransom-Everglades School. Ransom and his wife, Alice, transformed the camp into the Florida-Adirondack School that held spring and summer sessions in the Adirondacks and wintered in Coconut Grove. The New York campus closed in 1949, and the Grove site became the Ransom School for Boys. It merged with the Everglades School for Girls in 1974. (MCHMSF.)

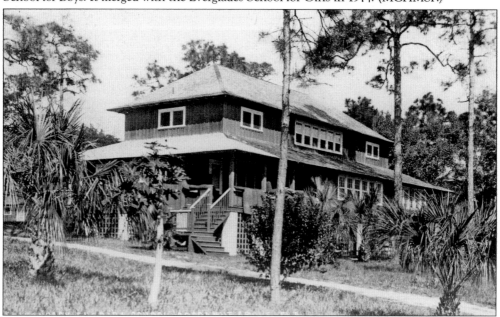

PRESERVING THE SPIRIT. In 1902, Paul Ransom added a unique building dubbed the "Pagoda" to his Coconut Grove campus. Designed by New York architects Green and Wicks and built by local people, the Pagoda—listed on the National Register of Historic Places—survives today on Ransom-Everglades upper school campus as a living testament to the spirit of Paul Ransom and his vision.

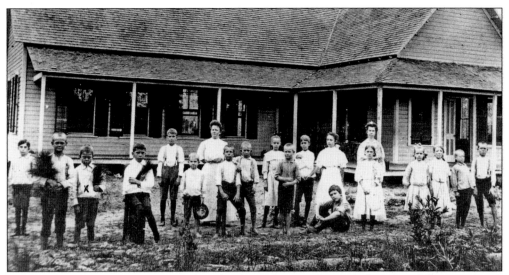

THROUGH THE WOODS. In 1894, as the school population increased, the men of the community built a two-room schoolhouse on today's Lincoln Avenue. Early students recalled walking through the woods to the new school. It served Coconut Grove students until a new school, designed by H. H. Mundy, was built on Matilda Street in 1911. After the Lincoln Avenue school closed, it became a private home and survived until the 1980s. (GS.)

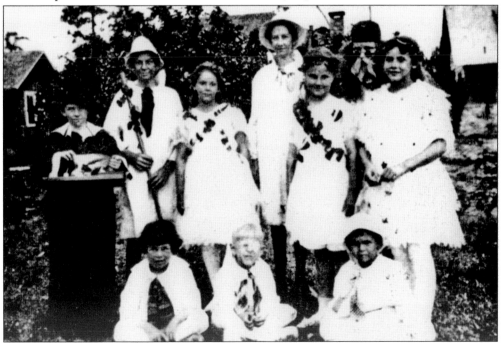

ANOTHER VISIONARY. In 1914, Julia Filmore Harris opened a private school in her home on Bayview Road. She quickly attracted the children of some of Coconut Grove's most influential families. From left to right are (first row) Augustus Saint-Gaudens, Irving J. Thomas Jr., and Lisperand Stewart; (second row) Daley Highleyman, Wirth Munroe, Helen Curtis, Patty Munroe, Natalie Wainwright, Tiffin Highleyman, and Dorothy Curtis. In later years, Julia's Florida school moved to Brickell Avenue, where it remained until moving to Stuart, Florida, in 1957. (Daly Highleyman.)

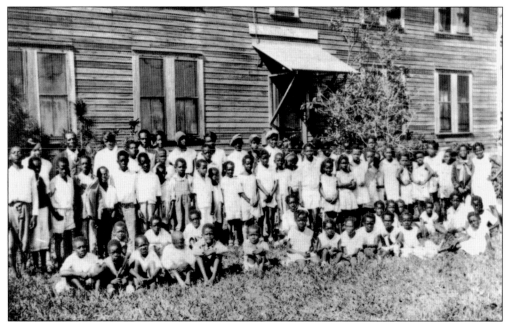

Bright Futures. St. Albans Episcopal Industrial School had many eager students in 1915. It was founded by African missionary Agnes Scott, who lived on Loquat Avenue. She gave 30 acres of land to the Episcopal Church for the school. The industrial school was located at the site of Tucker Elementary. (KSD.)

Another Beginning. In 1926, Arthur Gulliver founded the one-room Gulliver Academy on Main Highway and St. Gaudens Road. Noted educator Marian Krutulis purchased the school in 1954 and, over time, sold the Coconut Grove site and built new campuses in Coral Gables, Kendall, South Miami, and Pinecrest, making Gulliver one of the largest independent schools in Miami-Dade County. Today many of the original Coconut Grove buildings are part of Vanguard School.

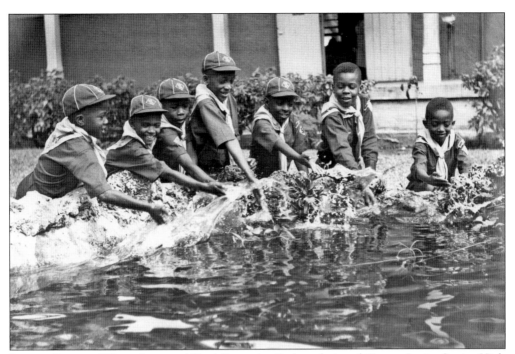

LITTLE CARVER. When the new Alfred Browning Parker–designed Carver Junior-Senior High opened behind the original school in 1951, the old school became Carver Elementary. Many community groups met at the school, including the Cub Scouts, who gathered around the patio fountain that was built by the WPA during the 1930s. From left to right are Fred Hunt, Ted Johnson, Lemond Jones, Edmond Armbrister, Tom Garvin, Jerry Grant, and Mike Hart. (BSUM.)

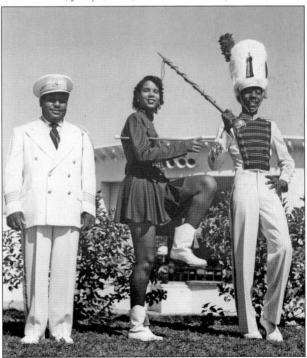

THE PRIDE OF COCONUT GROVE. The Coconut Grove community was especially proud of the Carver Senior High Hornet Band that frequently paraded down Grand Avenue. Band director Emerson Mason, left, stands next to head majorette Dorothy Powell and drum major Jacob Nelson. Carver Senior High became a junior high (now middle school) in 1966 when Coral Gables High School was integrated. (BSUM.)

71

SCIENCE AND HEALTH. In 1895, Bostonian Jesse Moore purchased a large plot of Coconut Grove real estate she named The Moorings. The following year, after coming under the influence of Mary Baker Eddy, she introduced Christian Science to South Florida, with Isabella Peacock as an early convert. At first, the congregation met at the Housekeeper's Club, but in 1914, Moore hired architect H. H. Mundy to build a permanent church on her land off Main Highway. It remains today, behind the larger sanctuary designed by August Geiger. (MPCUM.)

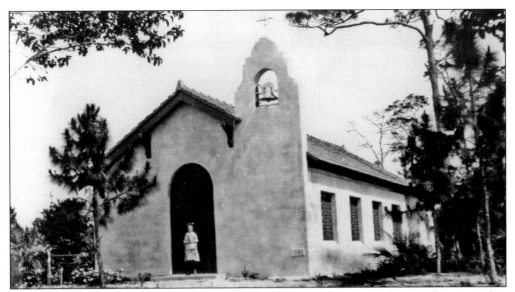

A Church with a Mission. In 1910, Flora MacFarlane called Grove Episcopalians together at Camp Biscayne to establish an Episcopal mission in the Grove. With the financial support of Coconut Grove luminaries like Kirk and Mary Barr Munroe, Ralph and Jessie Munroe, and William Matheson, the new St. Stephen's Church opened on Christmas day 1912. Fronting on Main Highway, parishioners added a cloister and decorative wall in 1920. The church was demolished in 2009.

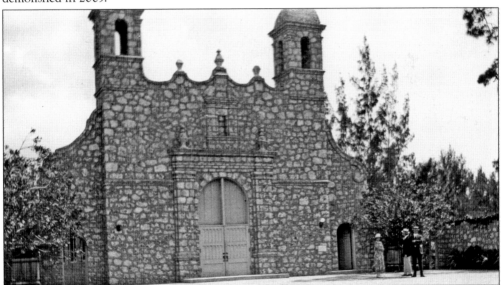

Plymouth Rock. Plymouth Congregational Church traces its roots to Isabella Peacock's Sunday school that began in 1887. In 1917, led by board chairman George Merrick and Rev. George Spalding, the congregation moved into the beautiful Clinton McKenzie–designed, mission-style, coral rock church. The stonemason was Spaniard Felix Rabon, who used only a hatchet, trowel, T square, and plumb line. In 1928, Harriett James purchased the 300-year-old door that now graces the church from the Spanish monastery in the Pyrenees. The campus contains several other notable rock buildings, some of which date to the Matheson estate that once encompassed the property. (MPCUM.)

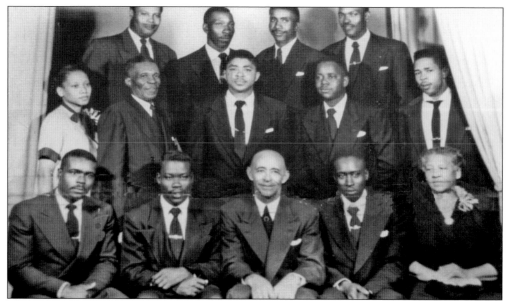

THE CHURCH ON THE HILL. Greater St. Paul African Methodist Church was founded in April 1896 by Rev. Jeremiah H. Butler. Their first wooden building on Evangelist Street, now Charles Avenue, also housed the first school for blacks. In 1935, the congregation built a new church on Douglas Road, where the male chorus was well known. From left to right are the following: (first row) James Darling, James Washington, George Members, George Butler, and Mother Mary Brown; (second row) Barbara Ann Dunn, Frank Brown, Thomas Holloway, David Ramsey, and John Holloway; (third row) James Robinson, Louis Washington, Charles Davis, and George Saunders. The present sanctuary was dedicated in 1993. (Greater St. Paul's AME.)

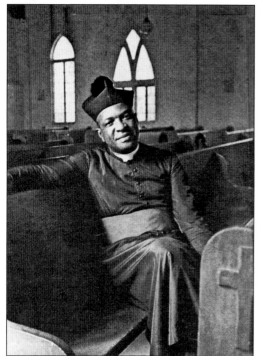

ONE OF A KIND. The Reverend Canon Theodore Gibson sits in the sanctuary of Christ Episcopal Church where he served as rector from 1945 until his death in 1982. Founded in 1901, Christ Church is the oldest Coconut Grove church in its original location. Father Gibson served on the City of Miami Commission and was a major civil rights leader. (TAG.)

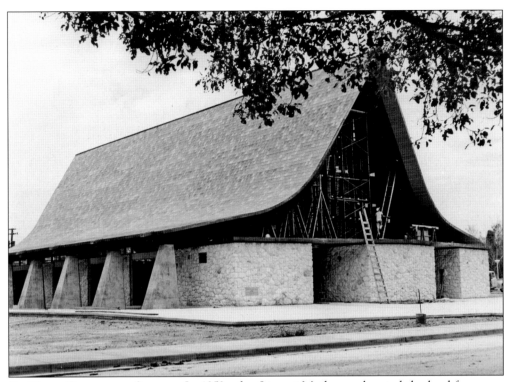

ST. HUGH PARISH AND SCHOOL. In 1959, after Liguori Matheson donated the land for a new Catholic church in Coconut Grove, Bishop Colman F. Carroll founded a new parish and named it St. Hugh in honor of her late husband. Completed in 1961, parishioner Murray Blair Wright designed the beautiful mid-century modern church and parish school. (SPA.)

A NEW BEGINNING. In January 1962, Carrollton School of the Sacred Heart opened in El Jardin, the former John Bindley Estate. Many of its early educators and students had recently fled Cuba, where schools run by Sisters of the Sacred Heart had been confiscated by the Castro government. The graduating class of 1971, seen here with Fr. Robert Braunreuther, included many individuals who would make their mark in South Florida. (Teresa Valdes-Fauli Weintraub.)

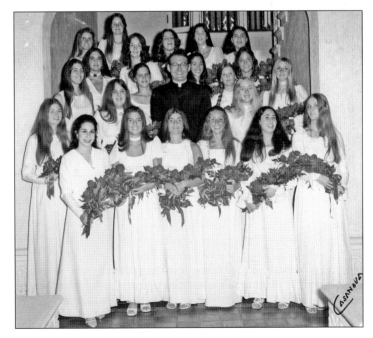

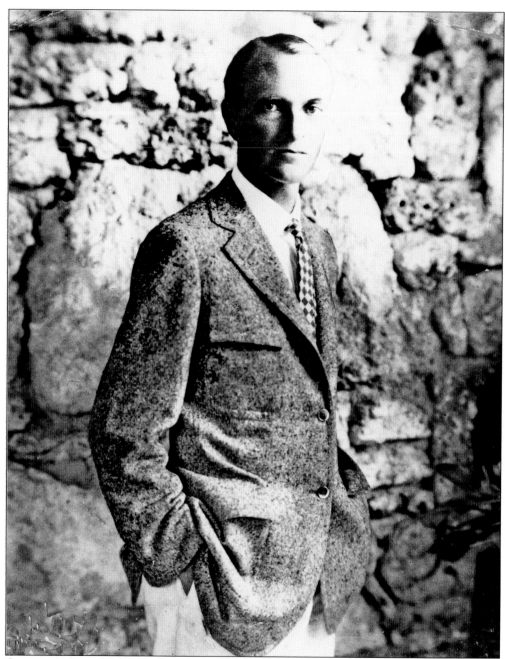

ONE OF THE BEST. Walter DeGarmo moved to South Florida in 1904. Trained in the Beaux-Arts tradition, he left the prestigious John Russell Pope firm in New York to join his parents who had recently moved to Coconut Grove. He is reported to be the first Miami architect registered with the American Institute of Architects. Besides his work in Coconut Grove, he designed many buildings in early Miami, Miami Beach, and Coral Gables. He died in 1951, but his legacy lives on through his work. (KD.)

Six

ARCHITECTURE AND THE CULTURAL ARTS

Coconut Grove has always attracted and nurtured creative people. It began with Ralph Munroe who, with no formal training, built the Barnacle, which continues to inspire architects today. He also designed Camp Biscayne, tucking a group of rustic cabins amidst the lush natural hammock. Forester John Gifford, another untrained architect, had a similar effect. After arriving in 1902, he built a group of bungalows that continue to speak to his passion for blending the man-made with the natural environment.

Walter DeGarmo was the first trained architect to arrive on the scene. Today many of his buildings are considered Miami, Coral Gables, Miami Beach, and Coconut Grove landmarks. As an early master of the Mediterranean style, he wrote how the beauty of Vizcaya influenced him and all the architects of his era.

As more northerners moved into the Grove, some brought talented architects with them. The most prominent and influential was the Pittsburgh firm of Kiehnel and Elliott. After Richard Kiehnel designed El Jardin and Cherokee Lodge, he opened a branch office in South Florida. Coconut Grove still claims many Kiehnel masterpieces. Other nationally known architects, like Clinton McKenzie and Robert W. Gardner, also left their mark.

The second flowering of Coconut Grove architecture came in the 1940s and 1950s when young architects trained in the International style moved to Coconut Grove. When they arrived, Grove residents Marion Manley and Robert Fitch Smith had already made the transition from traditional styles, like Mediterranean and Colonial Revival, to modern. They laid the groundwork for the coming modern architectural revolution. From their Coconut Grove home bases, the likes of Alfred Browning Parker, Rufus Nims, Robert Bradford Browne, George Reed, Lester Pancoast, Peter Jefferson, and Ken Treister helped define what is now called Miami Modern.

At the same time the young modern architects were beginning to be noticed, Grove-resident artists, like Eugene Massin and Tony Scornovacca, were busy making names for themselves and turning Coconut Grove into an artist colony.

Authors and actors also found a haven in Coconut Grove. Beginning with performances at the Housekeeper's Club and continuing with the opening of the Coconut Grove Playhouse, the Grove has a proud history of fostering and inspiring a variety of creative people and their work.

THE DREAM HOME. Walter DeGarmo was extremely busy during the 1920s and had great financial success. He was able to build a large home for his family on Douglas Road and Ingraham Highway. He built it around a courtyard that demonstrated his mastery and contribution to the development of South Florida's Mediterranean-style architecture. The home still stands as part of a walled subdivision called DeGarmo Estates. (KD.)

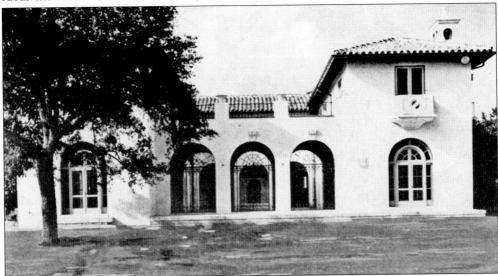

VILLA WOODBINE. Industrialist Charles Boyd hired Walter DeGarmo to design a home on the ridge overlooking South Bayshore Drive. It too has a large center courtyard reminiscent of Vizcaya. Today it is a popular place for weddings and other special events.

THE MASTER. In 1917, architect Richard Kiehnel of the Pittsburgh firm of Kiehnel and Elliott launched his South Florida career in Coconut Grove. He later designed many mansions, public buildings, and smaller dwellings that remain in Coconut Grove today. He is also remembered for Coral Gables Elementary, the Coral Gables Congregational Church, the Scottish Rite Temple, and many Morningside, Coral Gables, and Miami Shores homes.

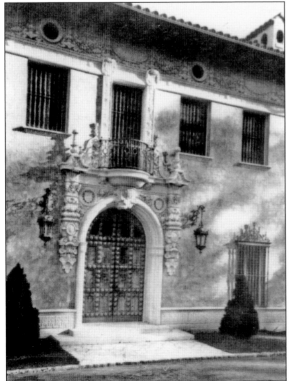

THE BEGINNING OF A NEW STYLE. Some say the Richard Kiehnel–designed El Jardin, more than any other building, set a high standard for others working in the Mediterranean style. It predated Mizner's Palm Beach work, and Kiehnel utilized unique ideas like aging his ornamental materials to give them a sense of instant antiquity in a brand-new place. It is now the Carrollton School of the Sacred Heart.

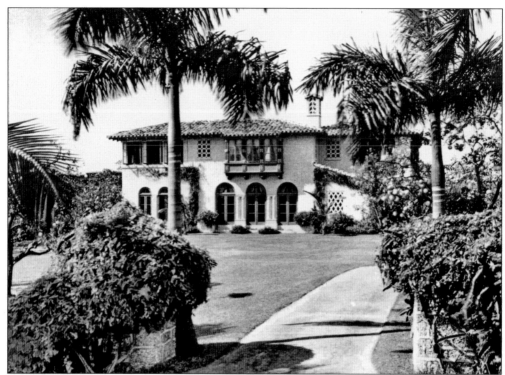

A Living Legacy. Another Richard Kiehnel masterpiece is the Irving J. Thomas home on Douglas Road between Poinciana and Leafy Way. It has recently been restored and the gardens enhanced and enlarged.

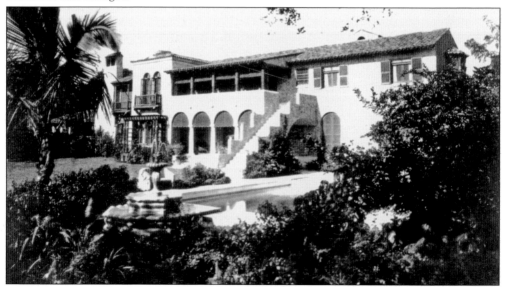

A Breeze on the Bay. Richard Kiehnel also designed La Brisa for Pittsburgh industrialist John B. Semple and his wife, Eleanore. It, along with El Jardin, was featured in an early book on Mediterranean-style architecture. Minna Field Burnaby was the second owner of the home that her son, renowned anthropologist Henry Field, inherited following her 1952 death. Henry Field; his wife, Julia; and their daughter, Juliana, lived in the home until his passing in 1986.

A Pioneer. In 1917, after graduating from the University of Illinois with a bachelor of science degree in architecture, Marion Manley moved to Miami and began the practice of architecture, first as an intern in the office of Walter DeGarmo and later as draftsman with August Geiger and Gordon Mayer. Although she designed some notable Mediterranean-style homes, her enduring reputation is as a modern International-style architect. Her most notable work is at the University of Miami. Her design permeates what became known as the nation's first modern campus. Widely honored, she died in Coconut Grove in 1984.

A Modern Master. Coconut Grove resident Rufus Nims, who moved to Miami in 1943, is considered one of the most influential post–World War II Miami Modern architects who helped create South Florida's distinctive tropical style. He is credited with developing concrete plate houses that other architects adapted. He was also the designer of the famous orange-roofed Howard Johnson restaurants and motels. An architect's architect, he inspired and mentored many other architects. He died in 2005. (SB.)

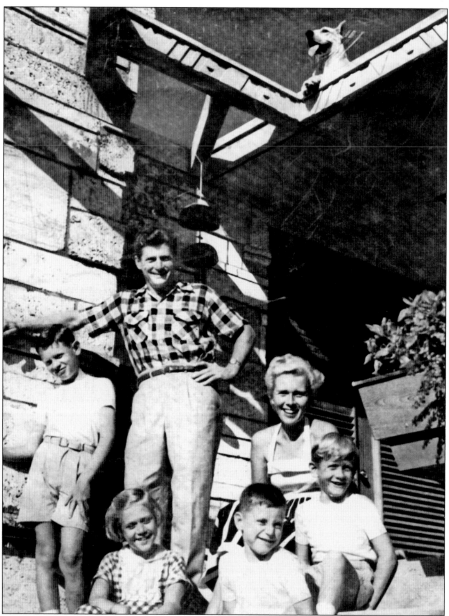

THE QUEST FOR AUTHENTICITY. Alfred Browning Parker grew up in Miami. His first wife was the daughter of noted naturalist John Gifford, who—although not an architect—designed and built many vernacular bungalows in Coconut Grove. Parker, influenced by the legendary Frank Lloyd Wright, melded Wright's organic ideals with South Florida's tropical ambiance. In 1953, he designed a home for his family in Coconut Grove that was deemed a "pace setter" in *House Beautiful* magazine. The magazine described his home as "an expression of a man and his family." Master photographer Ezra Stoller captured Parker with his wife, Martha, and their children, from left to right, Robin, Bo (Jules), Bebe (Gifford), and Derek. Great Dane Suzy du Parker is on the roof. Today Parker, emeritus professor at the University of Florida, lives in Gainesville and continues to inspire young architects. Recently, the Harn Museum of Art featured this home in a special exhibition. (Robin Parker.)

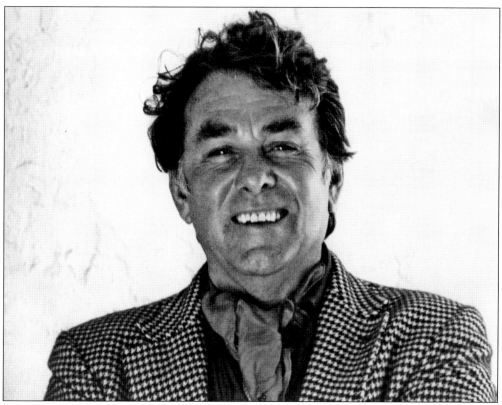

BREATHING GOD'S AIR. Robert Bradford Browne moved to Miami in 1952 and immediately began to influence Miami architecture. He loved tropical Florida and was famous for saying that buildings "should breathe God's air, let in his light, and shade our eyes." He designed residences with shady overhangs and large screened walls. The popular and much honored architect died in Coconut Grove in 1987 but inspired a generation of architects who gained prominence after working with him. (SB.)

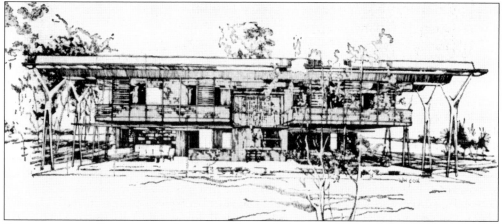

REINFORCING THE FUTURE. In 1960, Browne designed what was considered a daring experimental house for the John Vereen family. With distinctive Y-shaped precast concrete frames and screened walls, it made a strong, modern statement on Poinciana Avenue. *Look* featured the home in its January 1962 issue. Sadly, it has been demolished. (SB.)

IN A CLASS BY HIMSELF. In 1981, the Florida chapter of the American Institute of Architects presented George Reed with their highest honor. Reed continues to practice architecture today. (SB.)

LOVE OF NATURE. Lester Pancoast had a deep love of art, architecture, and the Florida landscape. Son of renowned architect Russell Pancoast and his artist/architect wife, Kay, and great-grandson of Miami Beach pioneer John Collins, Pancoast grew up in an enriched environment that continued after his marriage to artist Hélène Muller, great-granddaughter of naturalist David Fairchild. Besides designing buildings, including his own home on Poinciana Avenue, Lester also worked as a landscape architect and artist. His watercolors of tropical flora speak to his love of the lush green world he worked to protect. He died in November 2003. (Hélène Pancoast.)

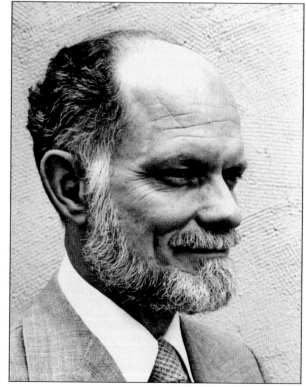

ARCHITECTURE AS ART.
Miami native Kenneth Treister graduated from the University of Florida School of Architecture in the early 1950s. In 1957, he built a home on Battersea Road with lush Grove landscaping at the center of the house—a concept he continued in his later work. As an artist and sculptor, as well as an architect, he was influenced by the natural forms of the art nouveau era as interpreted by the Spanish designer Gaudi, who combined three-dimensional decoration with architecture. Treister's artistry is apparent in his original Mayfair in the Grove and Mayfair House and in his moving Holocaust Memorial on Miami Beach. (Ken Treister.)

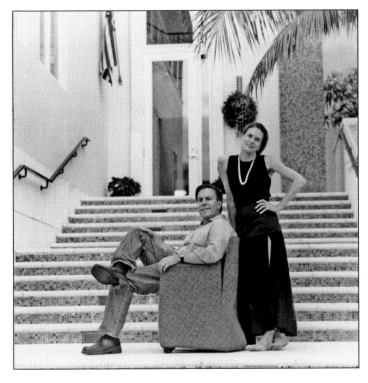

AT HOME IN THE GROVE. The internationally acclaimed husband-and-wife team of Laurinda Spear, FAIA, ASLA, LEED AP, and Bernard Fort-Brescia, FAIA, pose in front of their Coconut Grove home. In 1977, they formed an audacious new architectural firm called Arquitectonica that currently has three U.S. and eight international offices. The world took notice of the young architects after their Atlantis condominium hit the airways as the opening of the television show *Miami Vice*. (Maggie Silverstein.)

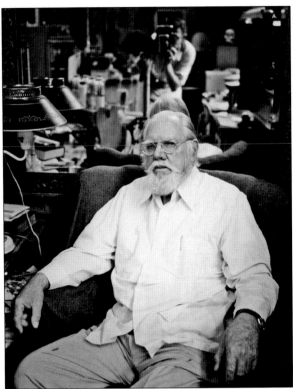

ARTIST IN RESIDENCE. Following World War II, artist Richard Merrick, brother of Coral Gables founder George Merrick, built a studio in Coconut Grove that became his sanctuary for the rest of his life. He was born in 1903 amidst a pine forest that would later become Coral Gables, and his mother, who also was an artist, encouraged his natural talent. In the 1920s, he attended the prestigious Art Students League in New York City, where he was inspired by teachers George Luks, John Sloan, Robert Henri, and etcher Joseph Pennell. He later became a well-known art professor at the University of Miami. He died in 1986, just two years after a final one-man show in Coral Gables. (MH.)

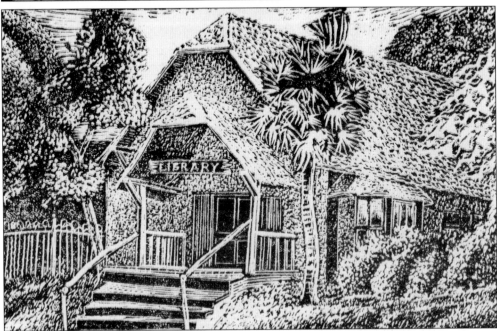

PRESERVING MEMORIES. Richard Merrick was famous for his etchings. This image of the Coconut Grove Library was especially important to him since the Union Congregational Church was next door. His father, Solomon Merrick, was the minister there when Richard was very young. All the Merricks frequented the library. (Mildred Merrick.)

Fostering the Artistic Spirit. In 1960, Lester and Hélène Pancoast, Otto Holbein, and James Merrick Smith created Grove House, a nonprofit marketplace in Coconut Grove where regional artists and craftsmen could show and sell their work. For many years, it was a fixture on Main Highway next to the Coconut Grove Playhouse. Many notable local artists launched their career there. In 1985, after Grove House closed, Hélène Pancoast started the BakeHouse Art Complex in the Miami Design District that continues to support the local art community. (CM.)

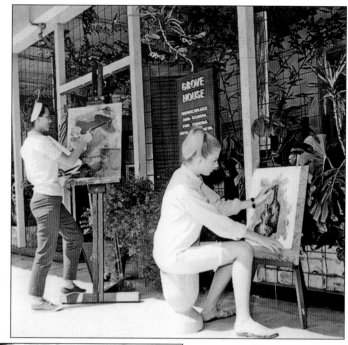

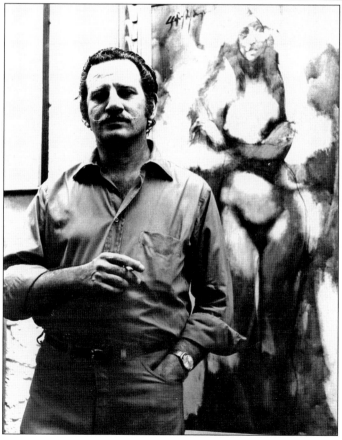

With Exuberance and Creativity. Tony Scornavacca was a much-honored artist who moved to Coconut Grove in 1950. Writer Meg Laughlin called him and the other young artists of the era "the stars, moon, and sun of Grove life." Well known for his sketches and paintings of nudes, Scornavacca also had his own gallery in the Grove and helped launch the first Coconut Grove arts festival. He died in 1986. (Tony Scornavacca Jr.)

THE MAGIC OF MASSIN. Artist Eugene Massin moved to South Florida in 1953 and, for the next 50 years, dominated the Miami art scene and helped make Coconut Grove an artist's haven. A nationally recognized award-winning painter, muralist, and sculptor, Massin was also a highly acclaimed professor of art at the University of Miami for 30 years. He moved into his historic stone home and studio on Little Avenue in 1959 and, for many years, held a Friday afternoon open house for students, friends, and art lovers. He died in 2003, but his work lives on in museums, synagogues, and homes throughout the United States. (Barry Massin.)

BROADWAY ON THE BAY. Oil millionaire George Engle discovered Coconut Grove in the early 1950s. He purchased a bay-front mansion that later became Coral Reef Yacht Club, and he built the Engle Building on Main Highway, despite the protests of old-time Grove residents. In 1955, he purchased the Coconut Grove theater and hired architect Alfred Browning Parker to transform it into a legitimate theater he called the Coconut Grove Playhouse. It opened on January 3, 1956, with the premiere of Samuel Beckett's play *Waiting for Godot*. (HMSF.)

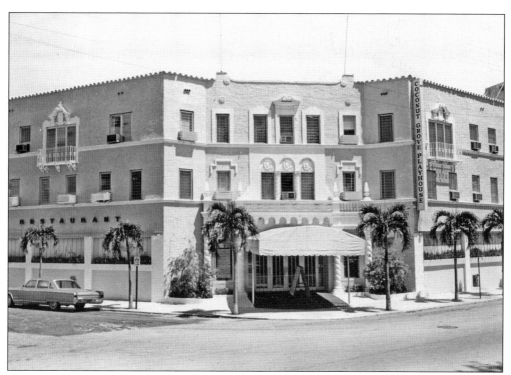

CREATIVE ANCHOR. The opening of the Coconut Grove Playhouse gave Coconut Grove a renewed creative spirit, spawned positive development, and added luster to its reputation as Miami's art and cultural center. (CM.)

IMPRESARIO EXTRAORDINAIRE. After six years of struggle, the Coconut Grove Playhouse found its muse in producer Zev Bufman, who drew in crowds with Broadway plays and super stars. Unfortunately, the Playhouse continued to have its ups and downs and is currently shuttered, though there is some hope of a future revival. (TGVP.)

THE DARING YOUNG MEN. Navy photographer Joe Pero, seated left, came to the new Dinner Key naval air station in 1918 and shot some of the area's earliest aerial photographs. Pero married Miami mayor John Reilly's daughter Eleanor and remained in South Florida at war's end. (JP.)

Seven

FLYING OVER THE SEA

Coconut Grove has a singular link to aviation history. In October 1917, just six months after the United States entered World War I and six years after Miamians witnessed their first airplane flight, the U.S. Navy began construction on the U.S. Naval Air Station, Miami. Their first order of business was to fill in the mangroves on a swampy parcel that joined a small island Miamians called Dinner Key. On the newly formed 32 acres of dry land, they sandwiched in 39 buildings, including barracks, machine shops, and five huge hangers.

Coconut Grove residents were not happy with the arrival of the U.S. Navy, but because the nation was at war, they grimly accepted what they considered a temporary intrusion. When the war ended in November 1918 and the government proposed making the station permanent, the Grove's patience vanished. Outraged at the suggestion, Grove residents took on those who favored its retention—especially the leaders of downtown Miami's chamber of commerce. Ultimately, the Grove residents prevailed, and in late 1919, the U.S. Navy moved its operation to South Dade's Chapman Field.

Although the Dinner Key naval air station departed, Dinner Key's aviation history was just beginning. In 1928, Ralph O'Neill convinced the City of Miami to allow him to open a base for his pioneering but short-lived New York, Rio, and Buenos Aires Line (NYRBA), the first to fly commercial flights to Latin America. O'Neill used a houseboat he towed from Cuba as his Dinner Key terminal. A few years later, Pan American Airlines, which was operating land service from today's Miami International Airport, purchased NYRBA. Pan American's legendary Flying Clippers soon called Dinner Key home.

In 1934, Pan American dedicated an art deco–style terminal that opened on March 25. It continued operation until World War II, when the U.S. Navy reestablished the station and put the Clippers under contract. At war's end, the City of Miami acquired the property and in 1954 made the terminal Miami City Hall. Recently restored under the direction of architect Richard Heisenbottle, the former terminal, with its impressive ceiling mural, illuminates the history of flight and Dinner Key's role in its development.

FLYING TOWARD THE FUTURE. Workers prepare the former marshland for the new air station. South Bayshore Drive, with its group of homes on the bluff, is visible in the background. Before it closed in 1919, the Dinner Key naval air station housed 1,500 men and 128 "flying machines." (Thelma Peters.)

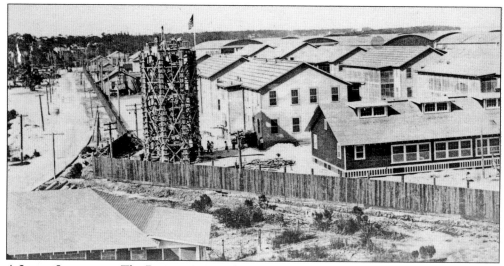

A LOCAL LANDMARK. The Dinner Key naval air station water tower, under construction in this 1918 view, survived for more than 50 years after most of the barracks and other buildings were gone. It stood at the foot of Twenty-seventh Avenue as a silent reminder of the once active naval base. (JP.)

OFFICERS AND MEN. In June 1918, the officers and men who launched the new naval air station line up in front of a just completed building for this historic photograph. (JP.)

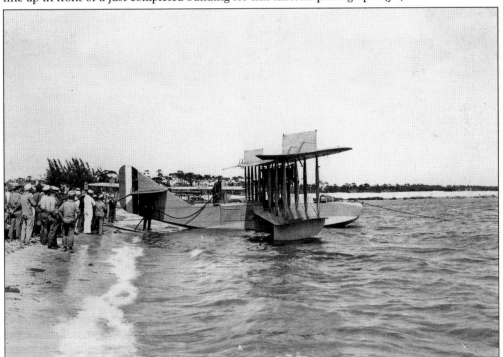

RUNWAY ON THE BAY. Navy personnel gather to help launch a plane onto the runway—the sparkling turquoise waters of Biscayne Bay. (JP.)

MIAMI'S FIRST GREAT AIRLINE. Ralph O'Neill's New York, Rio, and Buenos Aires Line (NYRBA) was the first commercial airline to fly from Dinner Key. In 1929, he piloted *Cuba* to bring the first airmail to Miami from South America. The wings of the plane were painted bright coral; the hull was a cream color to the water line, with black below. Hal Kemp and members of his band helped publicize NYRBA's pioneer flights. (R.)

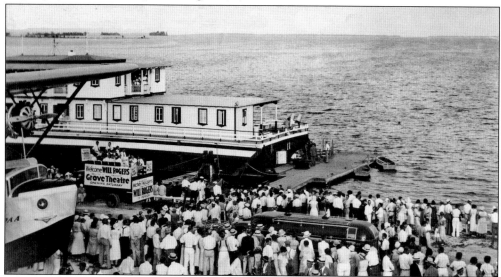

FLY 'EM COWBOY. In 1930, Pan American Airways took over NYRBA and its houseboat terminal at Dinner Key and shifted its operation from Twenty-sixth Street—now the site of Miami International Airport. Shortly thereafter, crowds gathered to greet famous humorist Will Rogers after an 18,000-mile trip from Los Angeles through Central America and around South America. "Miami is the springboard to the other Americas," he said. "Here is the hopping off place." (GS.)

94

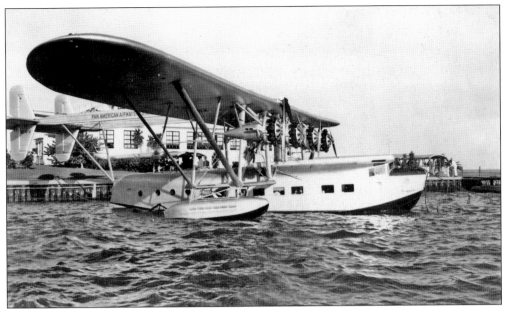

THE FLYING CLIPPER. The famous *Havana Clipper* takes off from the waters of Biscayne Bay. Tourists flocked to Dinner Key to watch the arrival and departure of the airplanes and their famous passengers, like Eleanor Roosevelt and movie stars Katherine Hepburn and Errol Flynn.

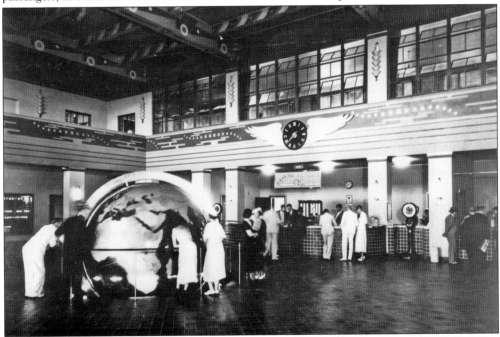

THE GATEWAY TO THE AMERICAS. Pan American added more than 13 acres to Dinner Key and, in 1934, opened a beautiful new terminal designed by Delano and Aldrich. It was once considered the largest and most modern seaplane terminal in the world. At the end of World War II, Pan American converted to land-based planes, and the City of Miami purchased the terminal property for $1 million. The globe in the middle of the photograph is now located in the Museum of Science lobby.

Mango Strut Anyone? Glen Terry and Bill Dobson, who founded the King Mango Strut Parade in 1982, are dressed for the trash dance, which was held the night before the parade. All who attended had to come dressed in garbage bags. The parade was born after the Orange Bowl Committee would not let the Merry Mango Marching Band, which played kazoos, banged on garbage cans, and wore conch shells on their heads, into the parade. The King Orange Parade is gone, but the Mango Strut is still held in Coconut Grove. (GT.)

Eight

THE GROVE LOVES TO PARTY AND PARADE

Coconut Grove has always had a reputation as a place to party and have a good time. In 1887, Charles and Isabella Peacock held what is considered South Florida's first social event—a Christmas party at the Bay View House for everyone who lived in what would become Greater Miami. A short time later, Ralph and Kirk Munroe organized a sailboat race and held a celebratory party afterward at the Bay View House. The Housekeeper's Club was known for its social events, and people lined up to attend benefits at the homes of some of Coconut Grove's richest residents.

The tradition continues today with a variety of fun events, including arts and food festivals, birthday parties, bed races, home tours, ethnic parties (like the Goombay Festival), and the wacky Mango Strut. From its early beginning as a publicity event for the Coconut Grove Playhouse, the Coconut Grove Arts Festival has earned national recognition.

Coconut Grove also loves and appreciates its history. Almost every weekend, something is commemorated. When Coconut Grove turned 100, everyone came out to mark the occasion. People flock to the Barnacle for music and entertainment and, of course, Ralph Munroe's birthday party. The historic Kampong hosts programs and events that remind everyone of the Grove's unique landscape.

Peacock Park, the site of the Bay View House that became the Peacock Inn, continues to be the favorite gathering place for entertainment and other community events. Streets remain the preferred route for a variety of parades. Even schools get into the act, and it is not unusual for the whole community to turn out for their special events.

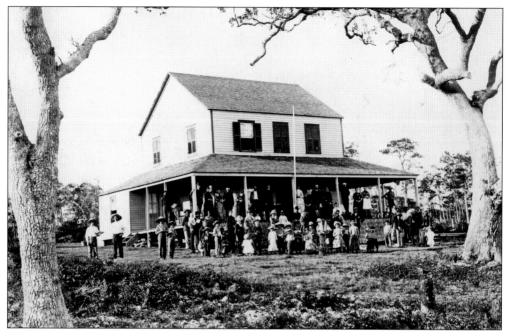

LET THE PARTIES BEGIN. In January 1887, the Peacocks invited every man, woman, and child who lived in what would become Greater Miami to a party at the Bay View House. Eye witnesses reported that almost everyone came. It was the first community-wide gathering ever held in Miami. (MCHMSF.)

ARMISTICE DAY PARADE. Citizens joined in a rousing Armistice Day parade down Main Highway, Coconut Grove's major business street. The building on the left, though altered, still anchors the corner. Sanders Peacock Store, with the second-story balcony, was one of the largest businesses in early Coconut Grove. Owner Arthur Sanders was the nephew of Isabella Peacock, the "mother of Coconut Grove." Today CocoWalk occupies the site. (R.)

PALM FETE PARADE IN DOWNTOWN MIAMI. Members of the Housekeeper's Club entered a decorated car in the 1920 Palm Fete parade. The Palm Fete later became the Palm Festival that was the forerunner of today's Orange Bowl Festival. (WCCG.)

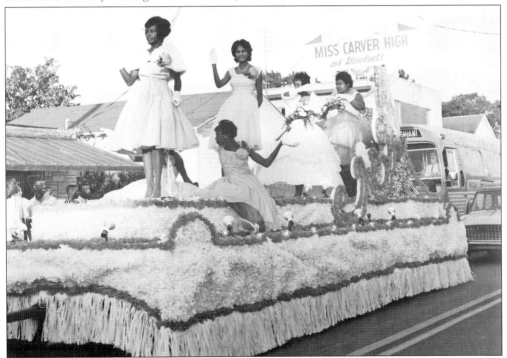

ROYALTY ON PARADE. Carver High School held its parades down Grand Avenue. Homecoming Queen Donna Scott sits to the right of Florence Gardner, who was named Miss Carver in 1962. They are joined by attendants Lenora Hobbs, standing in front; Phyllis Lane, standing; and Theresa Cambridge, sitting. (BSUM.)

COCONUT GROVE'S LEFT BANK. Charlie Cinnamon, publicity director of the Coconut Grove Playhouse, started the Coconut Grove Art Festival in the fall of 1963 in order to promote the Broadway play *Irma La Douce,* produced by Zev Bufman. Ethyl Blank helped and gathered about 70 artists who hung their artwork from clothesline on the sidewalks. From this modest beginning, the Coconut Grove Association organized to run the festival and sponsor a series of events that highlighted Coconut Grove history and culture. Today the Coconut Grove Art Festival continues as one of the nation's premiere outdoor art events. (CM.)

FULL CIRCLE. Glass artist Marilyn Catlow, granddaughter of Grove pioneer Ralph M. Munroe, exhibited her work at a recent Coconut Grove Art Show.

ALL ABOUT ART. In 2010, the Coconut Grove Art Festival celebrated its 47th anniversary. The festival attracts more than 150,000 people annually to view the juried works of over 300 of the finest artists and craftsmen in the world. In 2008, artists sold approximately $4 million in artwork. (CM.)

ALICE WOULD BE PROUD. The fifth annual Mad Hatter Art Festival kicked off in the fall of 2009. Artist Audrey Scott put together a hat that rivaled Wonderland's own. (HEG.)

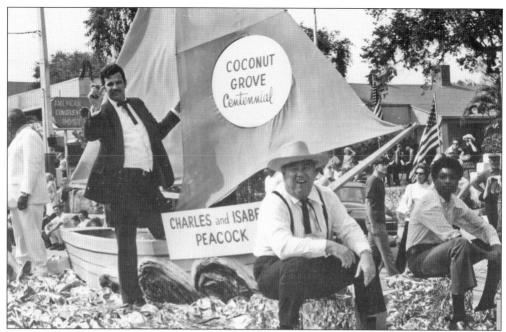

CELEBRATING THE CENTENNIAL. In 1973, Coconut Grove celebrated its 100th birthday with a series of community events, including a parade. Several members of Coconut Grove's first families—including Peacocks, Stirrups, and Frows—rode on a float that recalled their ancestors' contributions to the history of the area.

FIRST FAMILIES. One Centennial event brought the descendents of Coconut Grove's pioneer families together at Miami City Hall, where Mayor David Kennedy presented them with a proclamation. From left to right are Louise Stirrup Davis, Pearl Stirrup, and Kate Stirrup Dean, daughters and daughter-in-law of E. W. F. Stirrup; Leona Peacock Cayton, great-granddaughter of Charles and Isabella Peacock; Patty Munroe Catlow, daughter of Commodore Ralph M. Munroe; commissioner Rose Gordon; Mayor David Kennedy; Centennial chair Joe Harrison; Marge Perry, daughter of Mary Serena Pent Perry for whom Mary Street was named; Lawrence A. Peacock, grandson of early sheriff John Thomas Peacock; unidentified; Charles J. Frow, representing the pioneer Frow family immortalized in Frow, Charles, and Franklin Avenues; Lillian Stirrup Mazon, daughter of E. W. F. Stirrup; and Mary Munroe, widow of Wirth Munroe, son of Commodore Munroe. (CM.)

A Grove Legend. Billy Rolle, son of Coconut Grove pioneers Obediah and Rovena Bullard Rolle, was born in Coconut Grove in 1927. He graduated from George Washington Carver High School and Florida A&M University. He was a teacher, assistant superintendent for community education, a track and field coach, and a bandleader. The Coconut Grove post office is named in his honor. In 1976, he and his wife, Frankie, were two of nine who collaborated with the Bahamas Tourist Office to establish the first Goombay Festival in the Grove. He is seen here warming up for the event, which is one of the largest black heritage festivals in the United States today. (SPA.)

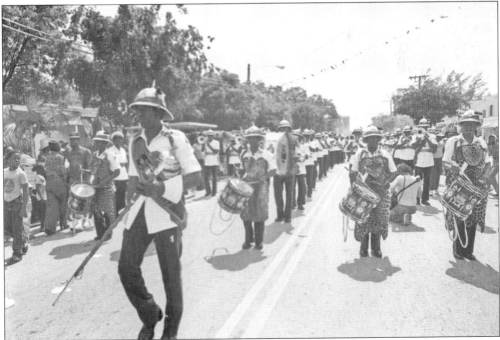

A Proud Heritage. The Goombay Festival's weekend of festivities includes music, Junkanoo bands, parades, activities for the children, and vendors selling a variety of arts, crafts, and food. The visiting Royal Bahamas Police Force Band, seen here, is always a crowd pleaser. (CM.)

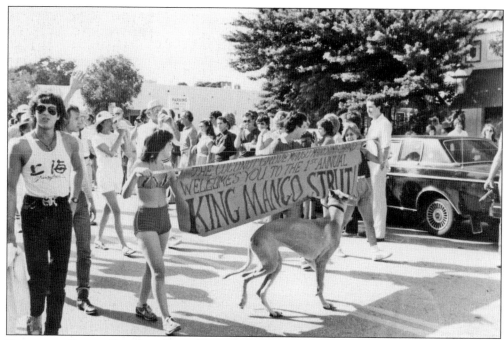

SPOOF AND STRUT. Founders Glenn Terry and Bill Dobson vowed that the famous tongue-in-cheek Mango Strut "would put the nut back into Coconut Grove." A travel writer agreed when he called it "the weirdest parade on the galaxy." (GT.)

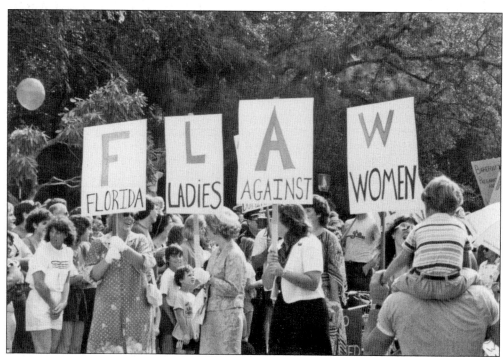

FLAW. The Florida Ladies Against Women made fun of anti-feminists and was a perfect example of the Mango Strut being full of irreverent, wacky people who parody everything. (GT.)

THE MARCHING MARJORYS. In 2006, a group of Coconut Grove activists who opposed moving Marjory Stoneman Douglas's Coconut Grove home marched in the Mango Strut to make others aware of the situation. The group, which included both men and women, posed in front of Douglas's Stewart Avenue home. (GT.)

BED AND BRAVADO. Viking Robb Parks enjoys his perch on the Barracuda Grill entry in the 2009 100-yard bed race entitled Bed, Dash, and Beyond. After a six-year hiatus, the Labor Day event returned and drew more than a 1,000 spectators to the streets of Coconut Grove for a fun-filled afternoon. The race benefitted the Alonzo Mourning Charities. (Alex Feldstein.)

PIONEER ZEALOT. Mary Barr Munroe and her husband, Kirk, moved to Coconut Grove in 1887. A fearless and outspoken leader, Mary was a woman ahead of her time. From the moment of her arrival until her death in 1922, she advocated for women and the Seminoles, stood up for blacks, fought for protection of birds and forests, and sought to preserve Florida history. (MCHMSF.)

Nine

GREEN BEFORE GREEN

Today everyone talks about wanting to be green. Long before anyone heard of the term, Coconut Grove pioneers understood the importance of appreciating and preserving the natural environment. The first to carry the green flag was Ralph Munroe, who, even before Miami was born, contacted the federal government about the need to protect the sea turtle. He convinced his neighbors to avoid outfalls into the bay and, instead, build septic tanks. In the 1920s, when developers wanted to build a causeway from Virginia Key to Key Largo, he went to court and stopped them.

Kirk and Mary Barr Munroe also cared about nature and the green world. They fought for birds—particularly the snowy egret that was being slaughtered by plume hunters. Mary also worked to protect the Everglades, leading the first charge to preserve it.

It is not surprising that this group of early activists attracted others. Forester John Gifford joined the group, as did David Fairchild, who discovered the Grove while working in the Department of Agriculture. In 1926, Marjory Stoneman Douglas built her home in Coconut Grove and spent the rest of her 108 years inspiring everyone who met her.

The Grove also spawned individuals like Charlie Brookfield, who spoke out for the natural environment and the birds that inhabited it. Likewise, Alice Wainwright discovered her voice after moving to Coconut Grove and left a legacy of achievement in politics and support for the special Grove ambiance she loved.

In more recent time, when Coconut Grove's tree canopy and special natural features were threatened, activists created the TreeMan Trust that does more than speak out. It teaches newcomers and those who do not understand about the importance of trees and fights for each branch.

Despite the intrusion of modern development, people who visit the Grove are still enchanted by the green world they encounter. Standing alone in a city that fosters all that is new, Coconut Grove maintains its character because, from the beginning, people have been willing to fight for its preservation. That dedication, along with eternal vigilance, continues unabated today.

THE GREEN FATHER. Ralph Munroe would have never heard the term green, yet he practiced its philosophy. His home, the Barnacle, had special features to capture the breeze. He protected the natural hammock, avoided polluting the bay, and sought to preserve the green turtle. (MFCUM.)

STANDING TALL. For many years, Kirk Munroe was Coconut Grove's most famous resident. A renowned author of boys' books, this prolific writer and adventurer penned more than 35 novels, many with Florida settings. He was one of the founders of the Florida Audubon Society and fought to preserve Coconut Grove as he found it. (MCHMSF.)

A Man for All Seasons. John Gifford, Ph.D., one of America's first foresters, moved to Coconut Grove in 1902 and, until his death in 1949, was a strong voice for conservation. A prolific writer, he penned books and articles about the unique South Florida environment and the necessity to preserve it. His first wife, Edith, helped lead the effort to create Royal Palm Park—the forerunner of Everglades National Park.

Living by the Land. Although John Gifford was not an architect, he designed many homes in Coconut Grove, including two for his family. "Build low of rock and timber," he wrote, "and when surrounded by vines and shrubbery, the house appears to grow out of the land." Several Gifford houses remain in the Grove today.

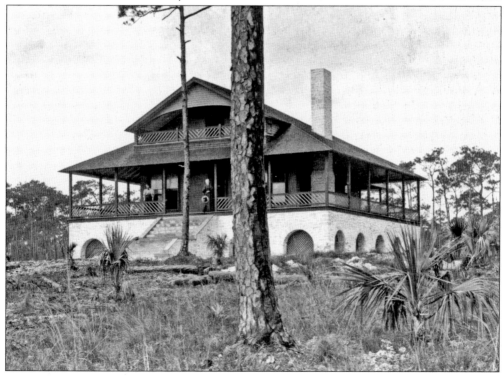

The World Grew 'Round His Door. David Fairchild, the internationally known plant explorer and chief of the Plant Introduction Section of the U.S. Department of Agriculture, and his wife, Marian, daughter of Alexander Graham Bell, purchased 10 acres of Coconut Grove bay front in 1916. In 1928, the Fairchilds built a new dwelling on the site they named the Kampong (a home in a garden). Renowned photographer Klara Farkas captured the Fairchild family at the Kampong. From left to right are (first row) Sally Bates, Marian Bates, Alice Bell Fairchild, Hélène Muller, and David Fairchild Muller; (second row) Hugh Bell Muller, Glenn Bates, Barbara Fairchild Muller, David Fairchild, Barbara Bates, Marian Bell Fairchild, and Nancy Fairchild Bates. (KF.)

Great Minds. Thomas Barbour Lathrop, left, world traveler and plant explorer, and Alexander Graham Bell, inventor of the telephone, had a contemplative discussion during a winter visit to Coconut Grove as guests of David Fairchild. Lathrop met Fairchild in the 1890s and convinced the young biologist to become a plant explorer. He financed his work and accompanied him on some of his early travels. In her book *Adventures in a Green World*, Marjory Stoneman Douglas chronicled their travels and Lathrop's friendship with Alexander Graham Bell.

OF WORDS AND WISDOM. Marjory Stoneman Douglas lived in South Florida for more than 30 years before she penned her 1949 classic, *Everglades River of Grass*. Reporter, magazine writer, and late-in-life powerhouse for Everglades restoration, Douglas built her English cottage on Coconut Grove's Stewart Avenue in 1926. Until her 1998 death at age 108, she personified the true spirit of Coconut Grove. (TGVP.)

FRIENDS OF THE EVERGLADES. In 1970, at age 80, Marjory Stoneman Douglas and her fellow travelers founded the Friends of the Everglades. Their original mission was to stop a proposed jet port. This success led the Friends to continue to fight by convincing politicians to join the cause. Gov. Bob Graham, himself an Everglades supporter, listened to Douglas during a 1985 airboat ride in the Everglades. (Bob Graham.)

TROPICAL DEFENDER. Charlie Brookfield was a popular Grove naturalist with a coterie of like-minded friends and fellow activists, like John Pennekamp, Juanita Green, Jean Bellamy, and Marjory Stoneman Douglas. He moved to Coconut Grove in 1924 and, during the Great Depression, built Ledbury Lodge fishing camp on Elliott Key. Following World War II, he defended the white ibis as the Audubon Refugee manager of the Shark River Valley. He died in 1988. (TGVP.)

LEADING THE WAY. In 1934, Alice Wainwright, a young widow with a small son, moved to Coconut Grove. When she turned 40, she went to law school and opened her practice in 1950. In 1961, she became the first woman to be elected to the City of Miami Commission and, four years later, the first woman vice mayor. A dedicated environmentalist, the City of Miami named the last natural hammock on Biscayne Bay Wainwright Park in her honor. (CM.)

A Sacred Trust. In 1995, Grove resident and landscape architect John Joseph Riordan left money from his estate to establish an organization that would protect Coconut Grove's lush tree canopy. With the leadership of activists Joyce and Ron Nelson and Jim McMaster, the Grove Tree-Man Trust was born. The all-volunteer organization provides advocacy, information, and funds to educate people on the value of protecting, planting, and caring for trees. Always vigilant, member Joyce E. Nelson stands guard in Coconut Grove's Peacock Park next to an historic oak tree. (Joyce Nelson.)

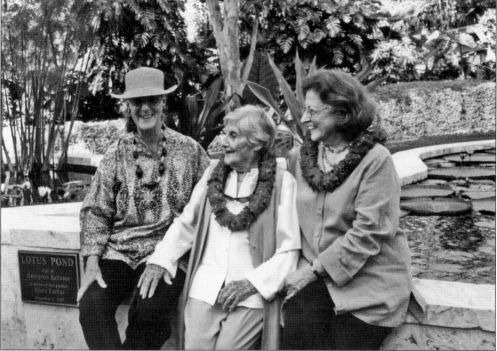

The World Still Grows 'Round Its Door. One of Coconut Grove's special places is the Kampong, the former home of David Fairchild that is now owned by the National Tropical Botanical Garden. In 2009, the Kampong's Lotus Pond was dedicated to photographer Klara Farkas. Farkas is joined by her daughter, Georgette Ballance, right, and David Fairchild's great-granddaughter, Hélène Muller Pancoast. (Lynda L. LaRocca.)

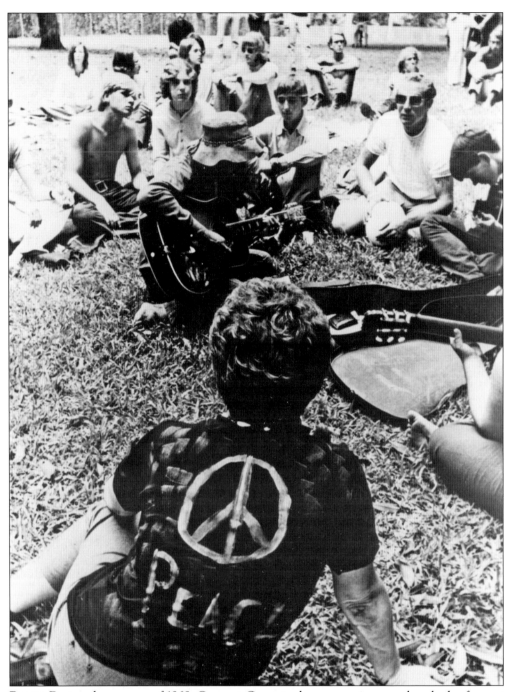

PEACE. During the summer of 1968, Coconut Grove took on a new image as hundreds of young people gathered in Peacock Park with their guitars, protest signs, tie-dyed shirts, beads, and bell-bottoms. Their goal was to buck the establishment and support an end to all wars—specifically the Vietnam War. (Miami News.)

Ten

"THE AGE OF AQUARIUS"

For most of its existence, Coconut Grove has been defined by an attitude of live-and-let-live. This caused a varied group of individuals from all walks of life—artists, writers, performers, architects, laborers, giants of industry, and fishermen—to call it home. The people who chose the Grove were not particularly concerned how someone dressed or if they lived in a tree house, on a boat, or in a mansion. They were more concerned about preserving the narrow, curving streets choked with green. If they wanted manicured lawns and sidewalks, they could live somewhere else. With a reputation like that, it is not surprising that in the mid-1960s—when America's youth rebelled against old ways, protested American foreign policy, and created what has been called a hippie counterculture—they, too, chose Coconut Grove.

With Peacock Park as the epicenter, hundreds and sometimes thousands of young people filled the park. They sang, protested, or just hung out, causing longtime residents to wring their hands in disbelief at what they considered an invasion.

Many merchants followed the trend and opened head shops that sold pipes, herbal products, and other paraphernalia associated with getting high. Others sold clothing favored by a counter culture that eschewed more formal dress. Some churches stepped up with soup kitchens and medical help for many of the young people who were stoned and homeless. It was a time like no other.

On the positive side, the 1960s youth revolution spawned a generation of talented folksingers who hung out in ubiquitous coffee houses all across America. The place to be in Miami was Coconut Grove. People flocked to listen to budding folksingers and entertainers share their passion for change.

Eventually, the Vietnam War came to an end, the young people got on with their lives, and the hippies left Coconut Grove. But despite the problems they sometimes created for the people of Coconut Grove, the young people left a legacy. Some of their protests and their songs resonated with the general population and helped bring about positive change.

LOOKING AT LIFE. In the mid-1960s, Coconut Grove became a magnet for young folksingers. The Grove's Gaslight South, owned and operated by Sam Hood, featured vocalists like Joni Mitchell, who was destined to become a music legend. (TGVP.)

"EVERYBODY'S TALKIN'." Grove resident Freddie Neil, who loved to sail, sing, and swim with the dolphins, was a house act at the Gaslight. He also wrote songs, including the famous Grammy-winning theme song for *Midnight Cowboy*, "Everybody's Talkin'." Some said it was a reflection of his life in Coconut Grove, "where the sun keeps shining, thru' the pouring rain." (TGVP.)

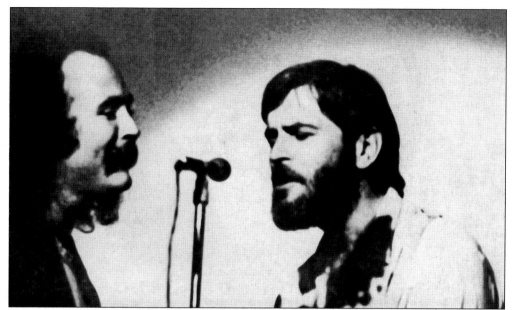

JUST A SONG. In the early 1960s, David Crosby, left, partnered with Grove musician Bob Ingram. They played at the Gaslight and other Miami establishments. Crosby was later inducted into the Rock and Roll Hall of Fame for his work with the Byrds and Crosby, Stills, and Nash. Bob Ingram still lives in Coconut Grove and is a popular South Florida performer. (TGVP.)

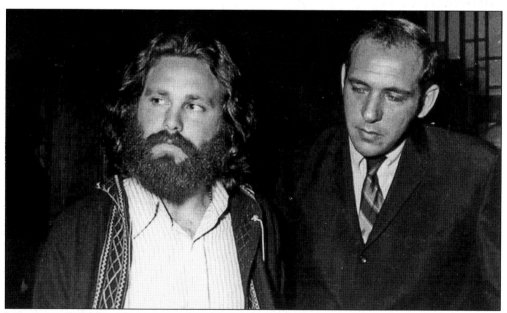

LIGHTING A FIRE. Jim Morrison was best known for being the lyricist and lead singer of The Doors. On March 1, 1969, during a concert at Dinner Key Auditorium, his behavior on stage led to his arrest. Represented by attorney Robert Josefberg, right, a Miami jury acquitted him of the felony charge of lewd and lascivious behavior but convicted him on indecent exposure and profanity. He was sentenced to two months in jail, along with two years probation. Released on bond, he appealed the verdict, but before his appeal was heard, he died unexpectedly in Paris in 1971.

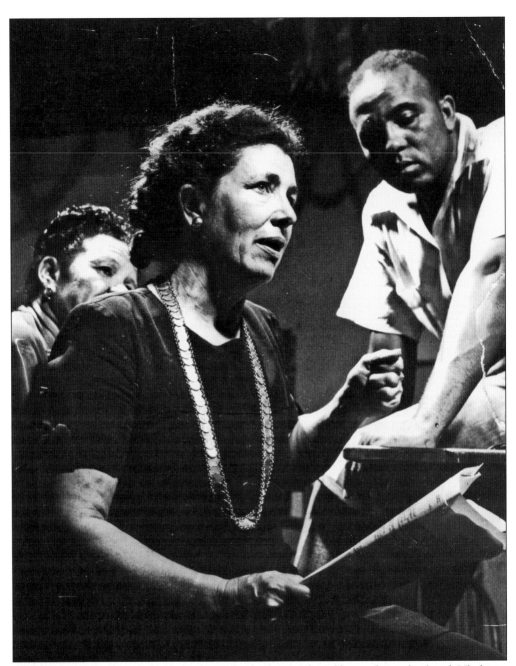

DETERMINED AND UNSTOPPABLE. In 1925, Elizabeth Virrick and her architect husband, Vladimir, came to Miami on their honeymoon and stayed. Although small in stature, she was a fearless woman ahead of her time. In 1948, after becoming aware of the deplorable conditions in black Grove, she organized the award-winning Coconut Grove Citizens Committee for Slum Clearance with Christ Church rector Fr. Theodore Gibson. They succeeded in bringing in water mains and outlawing the privy, and they fought tirelessly to uphold single-family and duplex zoning and stop the proliferation of large apartments they called concrete monsters.

Eleven

STANDING UP

The people who choose to live in Coconut Grove have never been afraid to take a stand, right a wrong, or fight for what they believe in. This home-grown brand of dogged determinism defines Coconut Grove and sets it apart. "Don't tread on me" would be an appropriate motto for hard-core Groveites.

When Mary Barr Munroe snatched egret plumes off ladies hats, she was building the Grove spirit. It incubated in the Housekeeper's Club and emerged strong and fearless when the ladies took on a cause. Other early groups, like the Coconut Grove Civic Club founded in the 1920s, kept the faith and passed the torch to others who followed.

A generation later, another outspoken woman, named Elizabeth Virrick, joined with Fr. Theodore Gibson to fight for slum clearance and racial equality. Her spirit continued when a group of Grove residents, including future school board chair Janet McAliley, then a PTA leader, helped integrate Coconut Grove Elementary before the courts forced them to do so.

Fighting overdevelopment has been the Grove's most difficult and enduring cause. Ralph Munroe fired the first shot when he went to court to stop Fair Isle, now Grove Isle. (Fifty years later, his family followed his example and refused to sell the Barnacle to a developer even though they could have reaped great financial gain.) The saga continued in the 1970s when the Coconut Grove Civic Club forced a compromise that stopped 40-story buildings on the same island. Recently, neighbors and those who wanted to protect Vizcaya's view shed went to court and once again kept another developer from building three 30-story buildings on nearby Mercy Hospital property.

Although a recent effort to once again secede from the City of Miami failed, continued frustration and antipathy toward the City of Miami spurred voters to create the Coconut Grove Village Council. Even though it has no political jurisdiction, it often gets its way.

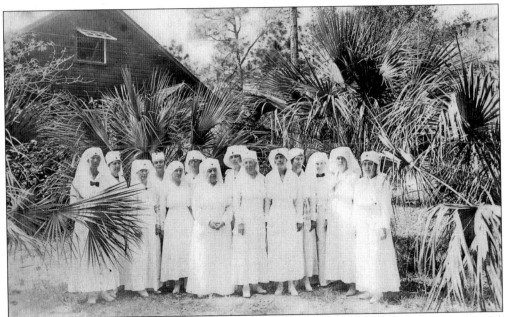

RESPONDING TO NEED. On March 7, 1917, Coconut Grove resident Harriet (Mrs. Arthur Curtiss) James invited a group of influential Miamians to her home, Four Way Lodge, with one thought in mind: she wanted to establish a chapter of the American Red Cross in Miami to aid the war effort. Within days, hundreds signed up. Many Coconut Grove women, seen here, joined other volunteers at a workshop at Camp Biscayne. (MFCUM.)

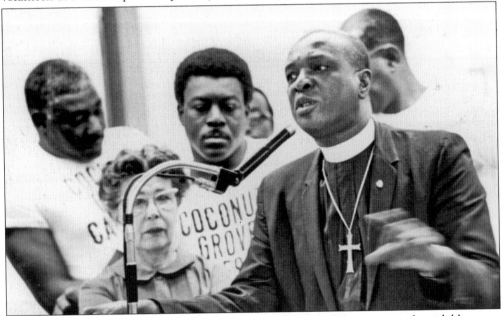

COCONUT GROVE CARES. Elizabeth Virrick, left, and Father Gibson were a formidable team. Although they are gone, their cause endures and has evolved as the community's needs changed. From civil rights in the 1960s, to ex-offender programs in the 1970s, to the 1990s opening of the Barnyard (a supervised place for neighborhood children), Coconut Grove Cares continues to do just that—care about the people of what is today known as the Village West. (TGVP.)

A New Day. In 1959, Coconut Grove Cares began pushing for a park and community gathering place in Village West. They focused on a 3.5-acre city-owned parcel on Plaza Street that the city had previously purchased to separate the black and white neighborhoods. Architect Ken Treister, center, shared his design for the park with commissioner Alice Wainwright, left, and Elizabeth Virrick. When it opened in 1963, it was named Elizabeth Virrick Park. Treister and architect Dick Schuster later designed a community center, indoor gymnasium, and library at the park. Recently restored, Virrick Park is a living testament to what can be accomplished when diverse members of a community work together. (CM.)

Doing What is Right. It is not surprising that one of the first successfully integrated schools in Dade County was Coconut Grove Elementary. Almost a decade before the 1971 federal court order paired a group of black and white schools, Coconut Grove Elementary quietly integrated its student body. In 1974, Gov. Rubin Askew came to the school to honor the students, teachers, and parents as leaders who made a difference. (Janet McAliley.)

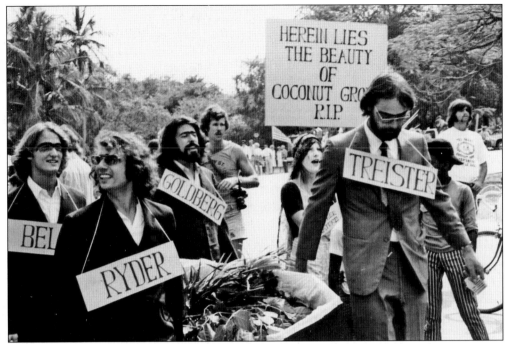

OUT WITH THE NEW. During the 1973 centennial parade, Coconut Grove activists protested the arrival of the Grove's first high-rise buildings. The fight to stop overdevelopment continues today as roused residents fight to keep the unique character of Coconut Grove intact.

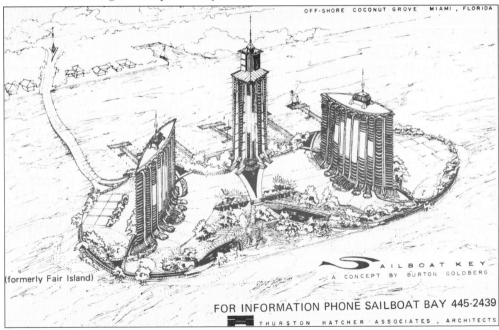

MAKING A DIFFERENCE. When developer Burton Goldberg announced plans to build three 40-story condominiums on Fair Isle, which he renamed Sailboat Key, activists went to court and successfully stopped the project. They later supported three 13-story buildings on what became Grove Isle. (TGVP.)

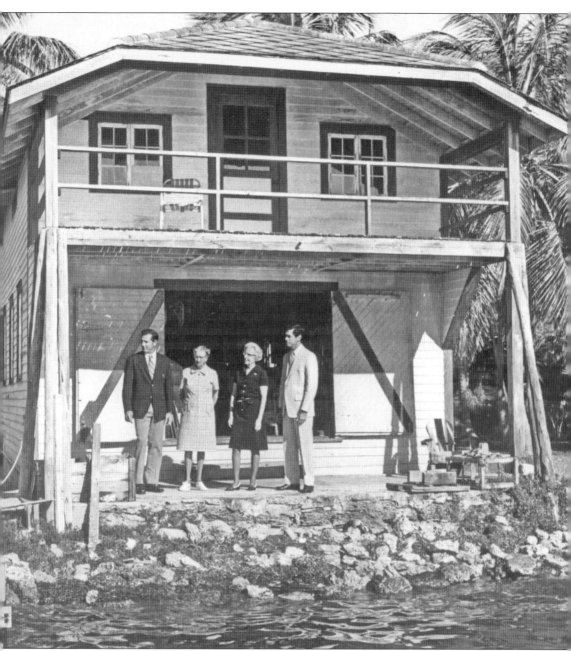

PRESERVATION OVER SPECULATION. The heirs of Ralph Munroe made history in 1973 when they turned down lucrative offers from developers who sought to rezone the Barnacle property for maximum development. Instead, they sold to the State of Florida for a lesser price in order to preserve it for future generations. Their decision not only saved the Barnacle but stopped encroaching high-rise buildings from continuing down the bay front south of MacFarlane Road. Standing in front of the Barnacle boathouse are, from left to right, Bill Munroe, grandson; Patty Munroe Catlow, daughter; Mary Munroe, Ralph Munroe's son's widow; and Charles Munroe, grandson. (MH.)

IT TAKES A VILLAGE. In the 1990s, Grove resident Pan Courtelis, right, led another effort to de-annex Coconut Grove from the City of Miami. Although the effort failed, Courtelis succeeded in getting voter approval for the creation of a village council. The council had no real power, but it galvanized those who wanted to maintain the Grove's special character and felt disenfranchised by City of Miami actions. (MCUM.)

A NEW BEGINNING. The first meeting of the newly elected Coconut Grove Village Council was held in January 1992. Council members included, from left to right, Robert Fitzsimmons, Carl Leon Prime, Charles T. Forehand, Herbert Lee Simon, Nancy Benouich, Richard E. Holton, Marsha G. Madorsky, W. Tucker Gibbs, Denise Wallace, Mary C. Weber, chairman Michael Samuels, David J. Gell, Neal McCool, and Miles C. Jennings Jr. (MCUM.)

A FRIEND OF THE LIBRARY. Helen Muir arrived in Miami in 1934 and moved to Coconut Grove a few years later. She was a columnist for both the *Miami Herald* and the *Miami News*, a radio broadcaster, and author of three books, including *Miami, USA,* published in 1953. After her daughter Melissa died, Helen turned to libraries as a memorial to her. She collected thousands of books, chaired the City of Miami Library Board, advocated for the book fair, and started the Friends of the Library. In honor of her leadership, the Florida Collection of the Miami-Dade Main Library was named in her honor. She died in 2005 at age 96. (KF.)

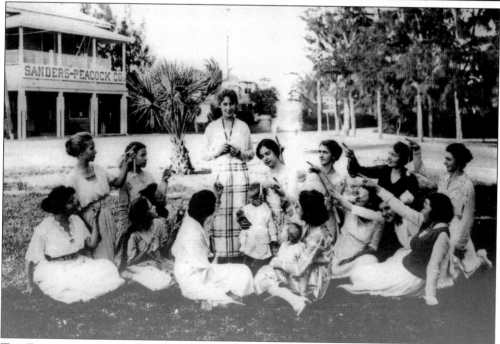

THE POWER OF WOMEN. The Women's Club of Coconut Grove, formerly the Housekeeper's Club, celebrated its 100th birthday in 1991. From the time of its founding to today, the club has fought for children, the poor, schools, clean water, parks, libraries, and other causes that would benefit Coconut Grove and the larger community. In the early 1920s, club members posed at the intersection of Grand Avenue and Main Highway to support one of their projects. (R.)

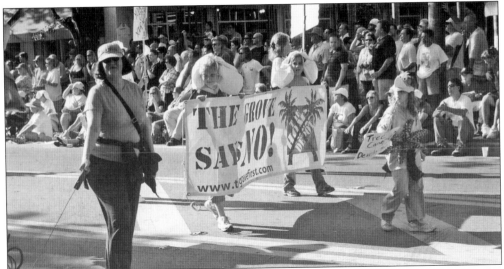

JUST SAY NO. In 2005, when Grove residents heard that Home Depot would be opening a big box store in Coconut Grove, a group of activists organized against it. Grove First, led by Mark Sarnoff, created placards with a bright orange drawing of the two original Coconut Grove trees in the classic "X" style. Yielding to the pressure, the Coconut Grove Arts Festival dropped Home Depot as a sponsor. Although Home Depot prevailed, residents claimed a half-victory when the City of Miami banned future big box stores in certain areas and filmmaker Joe Fendelman's documentary entitled *Don't Box Me In: The Coconut Grove Story* won national awards. In 2006, Sarnoff was elected to the Miami City Commission. (HEG.)

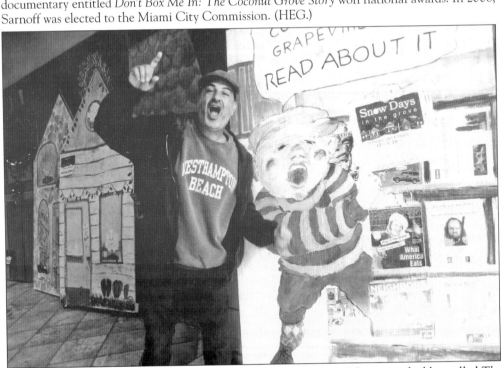

I READ IT ON THE GRAPEVINE. In May 2005, Grove resident Tom Falco started a blog called *The Coconut Grove Grapevine: The Daily News of Coconut Grove.* It soon caught hold and became a prime vehicle to inform, communicate, gripe, or take a stand. (AnnaMaria Windisch-Hunt.)

A FUTURE FOR THE PAST. Beginning in 2002, the University of Miami Center for Urban and Community Design collaborated with several Village West residents and organizations to create a master plan for the area. Students and faculty, together with residents, completed drawings, took photographs, did oral histories, and built model affordable homes that incorporated historic buildings into the design. From left to right are community activist Yvonne McDonald, project director; Samina Quraeshi; and Shirley Franco. (UM School of Architecture.)

A LANDMARK DECISION. When the Related Group, Florida's largest condominium developer, announced a deal with Mercy Hospital to acquire land to build three 30-story condominiums, neighbors and the Vizcayans, a Vizcaya Museum and Gardens volunteer support group, filed suit to stop them. In 2009, the court ruled in favor of the plaintiffs, giving those opposing overdevelopment a rare victory. Leading the effort were, from left to right, Donald A. Kress, Lynn M. Summers, John A. Hinson, Norma A. Quintero, Max Blumberg, and Vizcaya's executive director Joel M. Hoffman, Ph.D. (Vizcayans.)

www.arcadiapublishing.com

Discover books about the town where you grew up, the cities where your friends and families live, the town where your parents met, or even that retirement spot you've been dreaming about. Our Web site provides history lovers with exclusive deals, advanced notification about new titles, e-mail alerts of author events, and much more.

MADE IN THE

Arcadia Publishing, the leading local history publisher in the United States, is committed to making history accessible and meaningful through publishing books that celebrate and preserve the heritage of America's people and places. Consistent with our mission to preserve history on a local level, this book was printed in South Carolina on American-made paper and manufactured entirely in the United States.

This book carries the accredited Forest Stewardship Council (FSC) label and is printed on 100 percent FSC-certified paper. Products carrying the FSC label are independently certified to assure consumers that they come from forests that are managed to meet the social, economic, and ecological needs of present and future generations.

FSC
Mixed Sources
Product group from well-managed forests and other controlled sources

Cert no. SW-COC-001530
www.fsc.org
© 1996 Forest Stewardship Council

Find Your Place in History.